ANDREAS FEININGER: EXPERIMENTAL WORK

ANDREAS FEININGER: EXPERIMENTAL WORK

ANDREAS FEININGER

AMPHOTO
American Photographic Book Publishing Co., Inc.
Garden City, New York 11530

The author and publisher wish to express their sincere thanks to the following corporations that generously gave their permission to use in this book photographs made by the author for which they held the rights:

Prentice-Hall, Inc., Englewood Cliffs, N.J., for the photographs on pp. 18, 19, 20, 21, and 22, which were originally published in the author's book *Successful Photography,* © 1954, 1975; for the photographs on pp. 53, 84–85, and 131, which were originally published in the author's book *The Creative Photographer,* 2nd Edition, © 1975; and for the photographs on pp. 33, 49, 66, 68, 81, 95, 140, 141, and 142, which were originally published in the author's book *Photographic Seeing,* © 1973.

Morgan & Morgan, Inc., Dobbs Ferry, N.Y., for the photographs on pp. 102, 113, 121, 124, 131, 132, 133, 136, 137, 139, and 140, which were originally published in the *Monograph Andreas Feininger,* © 1973.

The Viking Press, Inc., New York, N.Y., for the photographs on pp. 106, 107, and 108, which were originally published in the author's book *Shells,* © 1972; for the photographs on pp. 115, 117, and 118, which were originally published in the author's book *Roots of Art,* © 1975; and for the photographs on pp. 88–89 and 92, which were originally published in the author's book *New York,* © 1964.

Time, Inc., New York, N.Y., for the photographs on the following pages, which were originally published in *Life* Magazine: pp. 84–85, © 1942; pp. 96, 99, 125, and 127, © 1948; pp. 98, 140, and 141, © 1949; pp. 86, 103, and 105, © 1950; pp. 102 and 104, © 1951; pp. 93, 113, and 119, © 1952; pp. 87, 101, 121, 129, 130, and 131, © 1955; and pp. 88–89, © 1963.

Published in Garden City, New York, by American Photographic Book Publishing Co., Inc.

Library of Congress Cataloging in Publication Data

Feininger, Andreas, 1906–
 Andreas Feininger: experimental work.

 1. Photography—Special effects. I. Title:
Experimental work.
TR148.F38 778.8 78-5167
ISBN 0-8174-2116-5 (softbound)
ISBN 0-8174-2441-5 (hardbound)

Manufactured in the United States of America

Books by ANDREAS FEININGER

Experimental Work (Amphoto, 1978)
New York in the Forties (Dover, 1978)
The Mountains of the Mind (Viking, 1977)
Light and Lighting in Photography (Amphoto, 1976)
Roots of Art (Viking, 1975)
The Perfect Photograph (Amphoto, 1974)
Darkroom Techniques (Amphoto, 1974)
Principles of Composition in Photography (Amphoto, 1973)
Photographic Seeing (Prentice-Hall, 1973)
Shells, with text by Dr. W. Emerson (Viking, 1972)
Basic Color Photography (Amphoto, 1972)
The Color Photo Book (Prentice-Hall, 1969)
Trees (Viking, 1968; reissued by Penguin Books, 1978)
Forms of Nature and Life (Viking, 1966)
Lyonel Feininger: City at the Edge of the World, with text by T. Lux
 Feininger (Frederick A. Praeger, 1965)
The Complete Photographer (Prentice-Hall, 1965)
New York, with text by Kate Simon (Viking, 1964)
The World Through my Eyes (Crown, 1963)
Total Picture Control (Crown, 1961; Amphoto, 1970)
Maids, Madonnas, and Witches, with text by Henry Miller and J. Bon
 (Harry N. Abrams, 1961)
Man and Stone (Crown, 1961)
The Anatomy of Nature (Crown, 1956)
Changing America, with text by Patricia Dyett (Crown, 1955)
The Creative Photographer (Prentice-Hall, 1955)
Successful Color Photography (Prentice-Hall, 1954)
Successful Photography (Prentice-Hall, 1954)
The Face of New York, with text by Susan E. Lyman (Crown, 1954)
Advanced Photography (Prentice-Hall, 1952)
Feininger on Photography (Ziff-Davis, 1949)
New York, with text by John Erskine and Jacqueline Judge
 (Ziff-Davis, 1945)
New Paths in Photography (Amer. Photogr. Publishing Co., 1939)

Contents

Introduction

Reasons and Necessity

"Experimental work"—what, exactly, does that mean? What is the difference between an "ordinary" and an "experimental" photograph? Why do any "experimental" photographic work at all? What's wrong with the "standard" photographic procedures; are they no longer good enough? Why do they have to be modified and supplemented by "experiments"? Isn't the term "experimental" simply a justification for photographic gimmickry, "tricks," or just plain sloppy work? Isn't it just a license to be "different," in order to make the pages of photographic magazines, attract attention, get your pictures published and your name in print—a license to appear daring and "in"?

That depends . . . There is no doubt in my mind that some so-called "experimental photographs" are nothing but the products of inept photographers who try to defend their bungled and gimmicky pictures as "in-stuff" and derisively call anyone who doesn't "understand" them "square." It is this kind of undisciplined work that has given experimental photography a bad name. This, I believe, is regrettable, and photographers who agree with this view make a serious mistake—a mistake that could stymie their development as makers of effective images for these reasons:

In my opinion, which, incidentally, is shared by all creative photographers, photography is not strictly a mechanical means of reproduction, nor are its products always "naturalistic." If this were true, any photograph that was correctly focused, exposed, developed, and (unless it is a positive color transparency) printed would automatically be an effective picture.

That this is not necessarily the case is proven by any number of technically perfect photographs in which a three-dimensional subject appears "flat" because the feeling of depth is lost; in which a moving subject seems to stand still because its motion was pictorially "frozen"; in which harsh lighting produces unnaturally black shadows that obliterate important detail; in which perspective distortion makes the subject look ridiculous, or tilting verticals make tall buildings appear as if they were on the brink of collapse. And neither does a black-and-white photograph that renders a colorful subject in shades of monotonous gray appear particularly "naturalistic"— nor one in which subject and background blend because of inadequate tonal separation, nor one that presents colors as contrasting as red and blue in the same shade of gray, nor one in which a lovely summer sky enlivened by fluffy clouds appears whitish, cloudless, and "bald." And the color photograph of a face tinged with overtones of red, yellow, or blue is anything but a "natural-appearing reproduction" of the original, no matter how accurately such shades may correspond to actual lighting conditions. The list goes on.

That even technically unassailable photographs can fail to fulfill the expectations of their creators is due to two factors:

1. The eye and the camera "see" the same subject in different ways.
2. Any subject can be photographed in an unlimited number of ways, some of them, of course, more effective than others.

Since these two premises comprise a rather formidable subject, I have devoted an entire book to their discussion (*Photographic Seeing,* Prentice-Hall), to which the interested reader is referred. Here, I must confine myself to a synopsis.

The differences in "seeing" between eye and lens can be summarized as follows:

1. The eye is part of a living and thinking human being; the lens is part of a machine. As a result, the eye, subject to the selective guidance and control of the brain, lets us "see" consciously only those things in which we are particularly interested. The objective lens, on the other hand, mechanically registers everything within its range of view, regardless of whether that matter is important, inconsequential, or detrimental to the effect of the picture. In other words, the subjective eye may show us a specific subject idealized and flawless, whereas the objective lens presents it as it actually is.

2. We always experience a photographic subject complemented and amplified by other sense impressions, such as sound (the cacophony of big-city traffic or the thunder of breaking waves), smell (the fragrance of pine trees, flowers, or Chanel No. 5), and touch (the feeling of differently textured materials, such as cloth, wood, stone, or human skin or hair). But a photograph is strictly limited to registering visual impressions, thereby often making it an incomplete and, therefore, disappointing record of the actual experience.

3. The eye shows us a subject as part of a greater whole, peripheral vision providing a smooth transition between the focus of our interest and the surrounding world. In contrast, a photograph shows the subject out of context, abruptly cut off by its edges, thereby making possible weaknesses stand out more glaringly than they appeared in reality while simultaneously eliminating ameliorating influences that happened to fall outside the field of view of the lens.

4. Human vision is stereoscopic; camera vision is monocular. As a result, we are able to perceive depth directly, while a photograph, being flat, can at best create only *illusions* of depth. I say "at best" because, unless the photographer is familiar with the photographic symbols of depth—light and shadow, "perspective," distortion, diminution, overlapping of forms, aerial perspective, and so on—his subject is likely to appear "flat" and his picture disappointing.

5. The angle of vision of the human eye is unalterably fixed, whereas cameras can be equipped with lenses encompassing angles of view that range from a few degrees to more than 180 degrees—from super-telephoto to fish-eye lenses. Such extreme lenses, of course, produce images unlike any the human eye could experience in reality. Some people reject such photographs as "distorted" and hence "unnatural"; others, more open-minded and enlightened, appreciate them as valuable extensions of our vision.

6. The focal length of our eyes, and hence the scale in which we see specific objects at specific distances, is always the same; in addition, there is a minimum distance of approximately eight inches below which the normal human eye can no longer distinguish anything sharply. As a

result, distant objects appear too small for us either to perceive detail or to see at all; objects that are too small to be seen clearly at our minimum viewing distance appear either more or less blurred or become invisible. In contrast, the camera can be equipped with lenses of any focal length and focused at any distance, thereby showing us in equal clarity the structure of a galaxy trillions of miles away or that of the eye of a fly.

7. The eye shows us reality in color; black-and-white photography transforms it into shades of gray. And while this at first may seem a weakness of the photographic process, upon closer reflection it becomes an advantage because it adds a new dimension to our vision and enables us to create images that, in power of expression, can far surpass the actual experiences that they depict.

8. The eye is unable to add weak light impressions until the sum of those impressions is powerful enough to enable us to "see"—the dimmer the light, the less we perceive, no matter how long and hard we stare. In contrast, as long as photographic emulsions are exposed to any light, even the weakest, and are given a sufficiently long exposure time, they are able to build up images by accretion until, at last, an apparently pitch-black scene appears in picture form as if it were photographed in daylight.

9. The human eye cannot function almost instantaneously, is incapable of "stopping motion," and is unable to clearly perceive objects moving at very high speeds—for example, the feet of a running horse, the wings of a hovering hummingbird, or whirling propeller blades. Photography, of course, can accomplish such feats with ease.

10. The eye cannot retain an image for any noticeable length of time, nor can it combine several impressions in the form of a single image; photography can do both. As a result, the camera enables us to retain visual impressions for any length of time and permits us to combine, in the form of single photographs, through multiple exposure or printing, objects captured in different phases of motion, photographed in different places, or recorded at different times.

The foregoing synopsis lists only the ten most obvious differences in the seeing performed by the eye and that performed by the camera. These, as well as six other less important ones, are fully discussed in *Photographic Seeing*.

The lesson to be drawn from these differences seems obvious to me: A photographer who simply points his camera at an appealing subject and "goes by the book" is more likely than not to end up with a disappointing picture—because the camera is both superior and inferior to the eye. The *good* photographer knows how to take advantage of its superior qualities and avoid the inferior ones. To accomplish this, he can choose from a large number of different means and methods of rendition. This is where my second premise comes in: *Any subject can be photographed in an unlimited number of ways, some of them more effective than others.* The following is a summary of the more important factors that determine the effect of a photograph over which a photographer can exert a considerable amount of control:

Scale of rendition. The shorter the distance between subject and camera, the larger the subject will appear in the picture, and vice versa. If the subject-to-camera distance is fixed and cannot be changed, the longer the focal length of the lens, the larger the subject will appear in the picture, and vice versa.

Direction of view. As photographers, we have the choice of front, side, or back view; view from above ("bird's-eye view")

or below ("worm's-eye view"); and, of course, any intermediate direction of view. Each will emphasize different aspects of the subject, show it in a different relation to its surroundings and in a different light, change the background and foreground, and thus create a different impression.

Angle of view. If a wide lateral sweep or relatively great height should be included in the picture, a wide-angle lens must be used; conversely, if the photographer wants to concentrate on a narrower section of his subject, a lens with a correspondingly longer focal length will enable him to accomplish this.

Direction of light. A photographer has the choice of front, side, top, or back light, and, if he works with artificial light, light from below. Since the ramifications of light and lighting are of paramount importance for the outcome of the picture, space limitations prevent me from going into details here; instead, I refer the interested reader to my book *Light and Lighting in Photography* (Amphoto and Prentice-Hall), where all the photographically important aspects of light are fully discussed.

Quality of light. We have the choice of daylight (one light source, relatively difficult to control) and artificial light (any desired number of light sources, relatively easy to control); "white" light, or more or less colored light (for example, early morning, late afternoon, or sunset light; also, deliberately filter-colored light); high-contrast direct light, "normal" semi-diffused light, or low-contrast, totally diffused or reflected light (daylight on an overcast day, in the open shade, and artificial "bounce light"); continuous light (the sun, incandescent lamps) or discontinuous light (speedlights and flashbulbs).

Color. As photographers, we are often free to choose our subject's colors (a red scarf instead of a blue one), our color arrangements, or our overall color shade (by means of filters). We can work with either complementary colors (like red versus green, or yellow versus blue) for strongest color effects; related colors (red, orange, yellow, and brown; or blue and blue-green); harmonious colors (any three colors connected by an equilateral triangle within the circle of the Munsell Color Wheel); warm colors (red, orange, and yellow) or cold colors (the blues and blue-greens); highly saturated colors, or pale colors and pastel shades. The whole fascinating subject of color in photography has been examined in depth in my book *The Complete Photographer* (Prentice-Hall).

Contrast. We have the choice of presenting our subject in normal, high, or low contrast, with an infinite number of gradations between the extremes. We can increase subject contrast if it seems too low or decrease it if it appears too high. The means for contrast control are light and the manner of lighting, film selection on the basis of gradation, exposure in conjunction with appropriate development, color filters, selection of paper of the most suitable gradation, and dodging and burning-in while making the print. These means and techniques are fully discussed in my book *The Complete Photographer* (Prentice-Hall).

Space and perspective. Since a photograph is flat, space in it can only be rendered in symbolic form. Fortunately, the means for creating illusions of three-dimensionality and depth are numerous, including, among others:

1. Four forms of perspective: academic rectilinear, "true" rectilinear, cylindrical, and spherical.
2. The apparent converging of receding parallel lines, the angle of convergence of which can be controlled through selection of a lens of

appropriate focal length in conjunction with an appropriate distance from the subject.

3. Distortion of form (windows rendered not as rectangles but as trapezoids, wheels shown not as circles but as ellipses, thus indicating obliqueness of view and therefore "depth").

4. Diminution of scale (contrast between near objects, which appear relatively large, and more distant objects, which will be rendered proportionally smaller).

5. Overlapping of forms.

6. Contrast between sharp and unsharp (selective focus).

7. Contrast between light and dark (aerial perspective).

8. Direction of light and shadow.

Complete information about these symbols and their uses can be found in *The Complete Photographer* (Revised Edition) by this author.

Subject motion. Since a photograph is a "still," movement in it can be rendered only in symbolic form. The most effective symbol of motion is directional blur, the degree of which can also be utilized to indicate the speed with which the subject should appear to move. Other motion symbols are panning, picture sequences, multiple exposure and exposure by stroboscopic light, graphs of moving lights made with the aid of time exposures, tilting of the image of the moving subject relative to the edges of the print, and composition, all of which are discussed in both *The Complete Photographer* (Revised Edition).

Additional photographic means and techniques. Here, too, the list of controllable variables from which the knowledge-able photographer can choose is impressive. It includes:

1. Cameras that are small, unobtrusive, light, and fast, and thus best suited for photographing dynamic subjects (people, action, wildlife, pets).

2. Larger, heavier cameras that produce pictures of higher technical quality for photographing static subjects (objects), and for indoor use and tripod work.

3. Lenses of different focal lengths, coverage, and speeds.

4. Filters in all the colors of the rainbow for precise control of color translation into shades of gray, color separation, and contrast control in terms of black and white, and overall color control in color photographs.

5. Polarizing filters for glare control and limited color control in color photography.

6. Small diaphragm apertures for extending—and large ones for deliberately limiting—the extent of the sharply rendered zone in depth (selective focus).

7. Shutter speeds that are high, normal, or low, each of which gives a different result in rendering subject motion, extending sharpness in depth (in conjunction with the corresponding f-stop), and producing the degree of density of the negative or color saturation of the transparency.

8. Films with widely varying characteristics with regard to "speed" (sensitivity to light), contrast gradient, graininess, and, with color film, manner of color rendition (more or less saturated colors, overall tone more toward red, blue, green, etc.).

9. Standard, fine-grain, or high-contrast developers.

10. Variations in developing time for higher or lower negative contrast.

11. Shorter or longer exposures during enlarging for lighter or darker prints.

12. Papers of different gradations from very soft to ultra-hard for almost complete control of overall contrast in the print.

13. Dodging and burning-in during enlarging for local contrast control.

14. Sectional enlarging (cropping), enlarging to different print proportions and different sizes.

The list continues—an almost endless choice of options that are at the disposal of any imaginative and knowledgeable photographer willing and able to utilize them to produce images that *precisely* express what he intended them to say.

Photographic "Finger Exercises"

As should be obvious from the foregoing, photography on the creative level requires more than slavishly following the rules that govern standard photographic procedures. There is a world of difference between photographs that merely provide *reproductions* of the subjects they depict, and those that present interesting, stimulating, and thought-provoking *interpretations*. The former show a subject more or less as the viewer knows it, thus offering him nothing new—they are mere record shots (nothing wrong with record shots, of course—in their proper places). But the latter can open the viewer's eyes and let him experience something he hasn't felt or known or thought before.

To produce photographs superior to the run-of-the-mill type that are cranked out daily by the million, a photographer must possess two qualities: vision and craftsmanship. Vision is the ability to recognize the essence of a subject. This requires sensitivity, genuine interest in the subject to be photographed, imagination, and that indefinable something called talent. Craftsmanship represents the skill necessary to translate visions into photographic terms, to implement ideas on film and sensitized paper in a form that precisely expresses what their originator intended to say. The first requirement is largely beyond the photographer's control—a person either is, or is not, gifted with sensitivity, imagination, and talent. But the second qualification—craftsmanship—can be acquired by anyone sufficiently motivated to make the effort. And the basis of this effort, besides dedication and hard work, is experimentation.

Experimentation, as I see it, consists of two parts: testing and experimenting. The difference is subtle but important. Let me explain:

Testing comes first, experimenting afterwards. Basically, testing is a selective process: *On a strictly scientific basis, we try to find out how good something is, or which of several similar items is the best.* Experimenting, on the other hand, is more empirical, less guided by rules than by inspiration, more adventurous, a process that can be summed up in the words:

"Let's see what happens, if . . ." Consequently, testing is subject to rigid rules, while experimenting is a free-for-all where anything goes. We "test" cameras, lenses, films, developers, etc., to find the particular design, brand, or individual item that is best suited to a specific purpose; then, having found this "ideal" product, we "experiment" with it to learn its range and limitations, to find out what it can and cannot do.

For example: A photographer wishes to add a new lens of a specific focal length and speed to his "stable" of lenses. Let's assume there are five candidates made by different manufacturers that qualify with respect to technical specifications. To find out which one is the best performer, he must test all five under identical and strictly controlled conditions. And if he is a perfectionist, having made his decision, he subsequently may borrow from his dealer three lenses of the selected brand and run a second series of tests on each, this time to determine which of the allegedly "identical" lenses is "the best." For as any experienced photographer knows, in actuality, two lenses are rarely precisely alike; there are always minute unavoidable differences (tolerances) in manufacturing. This is testing, which must be done in accordance with the following rules if the results are to be conclusive:

1. Standardize. Always use the same test equipment, setup, and conditions. Otherwise, results from different tests are not comparable.

2. Be very sure to exclude all factors that might accidentally falsify the test result. For example, in lens testing for sharpness, pay particular attention to the rigidity of the camera support, because even the slightest accidental movement or vibration will cause a corresponding degree of unsharpness in the test picture, which subsequently might be thought to be the fault of the lens. A sturdy tripod, support of a long telephoto lens at both ends, and use of a cable release to trip the shutter should prevent this. Other potential causes for disappointing test results are misalignment of camera and test chart, and sloppy focusing. To avoid the first, let an assistant hold a small mirror flat against the center of the test chart, and then adjust the camera position until you see in the viewfinder, after focusing, the image of the front of the lens being reflected in the mirror. To avoid the second possibility, take several shots maintaining identical conditions except for refocusing the lens before each shot. And, if at all possible, focus with the aid of a magnifier.

3. Keep accurate and complete records. In lens testing, for example, write important data, such as name of lens, serial number, focal length, and *f*-stop used in conjunction with the respective shot, on a small card; then tape this card to the test chart so that it appears as a permanent record in the picture. This is an infallible way to avoid later confusion (always a possibility if separate records are kept), provided, of course, the photographer does not forget to make the appropriate changes in these data (for example, the *f*-stop used) prior to each exposure.

Whereas the purpose of testing is to find out *how good something is,* the reason for experimenting is to learn *what something can do.* For example: A photographer working in black and white may want to find out how filters can help him to control color translation into shades of gray. This is important primarily in two respects: (1) to achieve tonal separation, in terms of black and white, of colors different in hue but similar or identical in brightness (for example, red and blue), which, uncontrolled, would appear in the picture as similar or even identical shades of gray;

and (2) to control the brightness value of specific colors in accordance with the requirements of the subject, the intentions of the photographer, and the mood of the picture. To be able to exert this kind of control, a photographer must know precisely what the effect of specific color filters will be upon specific colors. This he learns from experimenting—in this case, by photographing a colorful test object through all the filters from red to blue. The result would be a series of pictures alike in all respects except one—color translation into shades of gray. Such a series would become a priceless reference set forming the basis for future creative work.

Normally, of course, nobody would photograph the same subject with several different lenses or through filters of several different colors. But this is the price of learning, of developing craftsmanship, of acquiring mastery over one's medium. Such exercises are analogous to the "finger exercises" of the future pianist or violinist —the "scales" they have to play to achieve mastery over their medium, perfect their "technique," and eventually be able to produce any required or desired tonal effect at will.

Later I will discuss some of the "finger exercises" that I did over the years, the oldest ones dating back to 1929. I consider them the key to mastery of photographic expression, indispensable for the artistic growth of any creative photographer and the production of any creative work.

Knowledge into Performance

The creation of any valid work involves three ingredients: original ideas, professional knowledge, and practical skills. This, of course, is also true in photography. Without original ideas complemented by the ability to "see in terms of photography"—the power to previsualize the future picture—no photographer can rise above a level of mediocrity. Without professional knowledge—a thoroughgoing familiarity with and understanding of not only the means and methods, but also the range and limitations of his medium—no photographer can successfully translate ideas into graphic form. And without the skill to apply effectively the specific means chosen to transform ideas into images on color film or sensitized paper, no valid photographs can be made. Although this may sound self-evident, the fact remains that very few photographers have original ideas, are gifted with photographic vision, or know how to transform their often encyclopedic photo-technical knowledge into performance. Such photographers, I hope, may profit from my own experience.

I started my professional career as an architect. Being blessed with a curious mind, I was interested in everything connected with my profession and wanted to see, learn, and know anything that might prove beneficial to my work. This meant making copious notes complemented by drawings. Sketching, however, as I soon found out, was both inaccurate and slow, so I acquired a camera and taught myself photography. I never went to any photoschool. Instead, I carefully read and followed the operating instructions that accompanied my photographic equipment and the processing instructions included with my plates. For this was in 1926, and cameras designed for use with glass plates were vastly superior to the amateur-type roll-film "Kodaks."

For a while I cruised happily along following instructions, sticking to the prescribed routine and producing technically unassailable but otherwise unexciting photographs, which, however, fulfilled my requirements, since all I needed were record shots. Then, a fortunate accident happened in my primitive darkroom while I

developed a plate: I accidentally turned on the white light. I instantly realized my mistake and flipped off the switch, hoping against hope that the brief exposure would not ruin my negative. But it was too late, the damage was done; the plate began to turn black in its entirety. But while I watched in fascinated horror, I noticed a curious thing: The encroaching blackness seemed to stop short of important outlines of the subject. The effect was so unexpected that I yanked the plate out of the developer and transferred it to the hypo, thereby arresting the process. Subsequent examination of the fixed negative in transmitted light revealed a delicate tracing of spidery lines on a black background, interesting enough to induce me to wash and dry the plate, and then make a print. The result was delightful, an interpenetration of positive and negative picture elements within a web of thin black lines—I had "discovered" the process of solarization. This was years before I heard of similar experiments conducted by Man Ray in Paris. And it was this "lucky accident," shortly followed by another one, that set my mind to thinking and made me aware of the infinite potential of photography if practiced creatively.

The second accident occurred while I was washing fixed glass plates: Gradually, the running water turned warmer until the emulsion of my negatives began to reticulate and frill along the edges of the plates. Luckily, I discovered the impending disaster before it was too late and the emulsion melted off completely. Here again, the "ruined" negatives appeared so interesting that I couldn't resist making some prints— I had "discovered" the process of reticulation. And this phenomenon, too, seemed to have such graphically exciting possibilities that I began experimenting with it and soon learned to control the results; some of the reticulated images that I made at that

time are shown on pp. 48–51.

Once creative awareness has been aroused, its own momentum will carry it to further heights. In my own case, the consequences were systematic exploration of what I then called the "graphic control processes"—solarization, reticulation, negative prints, the bas-relief process, photograms (direct projections with the aid of an enlarger), and combinations of two or more of these techniques. Some of the results are shown on pp. 42–71. The specific methods are described in my book *Darkroom Techniques,* Vol. II (Amphoto). A monograph on my graphic experiments was published in 1939 by American Photographic Publishing Co., Boston, under the title *New Paths in Photography.*

When the adverse political and economic conditions of the 1930s forced me to abandon my architectural career, I turned to photography. Making use of my connections with other architects, I became an architectural photographer. At that time I lived in Stockholm, one of the most beautiful cities in the world. Needless to say, I couldn't resist documenting its beauty photographically. Among Stockholm's greatest attractions are the broad expanses of open water around which the city is built. During the summer months these waters are graced by a succession of giant tourist ships, but, unfortunately, distances are so great that photographs taken with lenses of standard focal lengths are totally ineffective.

At that time—1934—telephoto lenses were rare and expensive, way beyond my limited financial means. So I constructed my own telephoto camera (see p. 72). It consisted of two wooden boxes, rectangular in cross section, sliding one inside the other for focusing, made lighttight with baffles lined with black velvet, and equipped with an ancient telephoto lens in a long and impressive brass barrel mount

that I had bought for a song the previous year at the Paris flea market. Its focal length was approximately 28 inches, my negative size 6½ × 9 cm. Stopped down to $f/22$, it yielded pictures that were surprisingly sharp and more than adequate for my purposes. These telephotographs, which, as far as I know, were the first of their kind ever made, formed the backbone of my picture book *Stockholm* (Albert Bonniers förlag, Stockholm 1936).

A few years later, I worked with similar old-fashioned, super-telephoto lenses with focal lengths of up to 40 inches, in conjunction with improved, home-constructed telephoto cameras, to document the city of New York. I used my cameras at first only from great distances, but later in the streets themselves, an application of extreme telephotography that, I believe, was another "first" in the field of creative photography.

Later, when I got interested in extreme close-up photography, I encountered the same problem: Equipment suitable for my purposes was either unavailable or prohibitively expensive. So the only solution was to design and construct my own. This proved simpler than I thought. The main elements of my close-up camera were the front and back of an ancient wooden 4″ × 5″ view camera connected by a custom-made bellows which, fully extended, spanned 48 inches. This contraption ran on a wooden track consisting of a board 8 inches wide, 1 inch thick, and 6 feet long that served in the manner of an "optical bench" insofar as it also provided the track for auxiliary devices, such as different kinds of subject stages and background supports, all of which I made of inexpensive metal parts and wood. The camera, of course, could be equipped with lenses of any focal length which, if necessary, by means of simple adapters, screwed into a large Ilex shutter permanently attached to the front of the camera.

This outfit worked so well that I was able to get tack-sharp close-ups of the eyes of live insects, which filled the entire 4″ × 5″ negative format (see p. 104). Three long dowel sticks—one hooked to the front of the camera, another to the subject stage, and the third to the background support—enabled me to sit comfortably behind the ground glass to focus and make other adjustments by pushing or pulling these rods, thereby manipulating those parts of the setup which, from my focusing position, were beyond the reach of my hands. And as a final refinement, I calibrated these rods in such a way that, by simply aligning two marks, I could instantly focus on any subject at any desired degree of magnification with any one of my three favorite lenses: a 40 mm Zeiss Luminar, a 100 mm Zeiss Luminar, and a 24 cm Zeiss Apo-Tessar.

I was motivated to compile this book for two reasons: to make some of my experimental work available to interested people (what good are photographs if nobody sees them?), and to prove that the quality and value of a photograph are not necessarily proportional to the cost of the equipment with which it was made. As they say: Money isn't everything, and the best things in life are free. Like most clichés, this one also contains an element of truth: Ideas, imagination, and resourcefulness are free, whereas even the most expensive photographic equipment, in the hands of duffers, yields only duds. Good photographs are the result of ideas, dedication, imagination, and skill. Compared to these ingredients of good photography, the camera, although indispensable, plays only the same subordinate role as a piano under the flying hands of an inspired concert pianist.

Notes on Technique

Examples of Photographic "Finger Exercises"

The following picture sequences illustrate how a curious and creatively motivated photographer methodically explores the potential of his medium. They represent only a small sample of all the experiments I have performed over a period of almost 50 years. Some I did for my own education—because I wanted to find out what can be done in specific respects; others I made as part of the illustration of my photographic texts.

In contrast to academic photography with its insistence on standard procedures and "normal" results, these experimental photographs explore specific aspects of photographic rendition in depth—from one extreme to the other. Consider, for example, the first series, which deals with film exposure. According to the rules of academic photography, there can be only one perfect exposure in any given case. All other exposures are either too short or too long and result in "underexposed" or "overexposed" negatives. But the creative photographer realizes that what might be right in one instance may be wrong in another. Accordingly, he examines the entire spectrum of possibilities and, in this case, photographs the same subject in a series of

steps that range from total underexposure to total overexposure—and makes some interesting discoveries in the process. He learns, for example, that any variation in exposure influences the contrast gradient of the negative, increases or decreases the amount of shadow detail rendered, affects the degree of lightness or darkness of the picture, and changes the mood of the scene. He then files these facts away for future use.

Unlike academic photographers with their rigid concepts of "right" and "wrong," creative photographers know that even "faults" can have expressive value, as for example, graininess, lens flare and halation, perspective distortion, or unsharpness and blur. Although traditionally considered "faults," in specific cases, these normally undesirable forms of rendition may be precisely what is needed to express in picture form characteristic subject qualities, the photographer's reaction to what he saw or felt, or the mood of the scene. But only photographers who are free from preconceived ideas, who are open-minded and receptive to the unconventional and unexpected, will be able to make use of these "hidden" potentialities of their medium and thereby produce pictures that show even old, familiar subjects in new and stimulating forms.

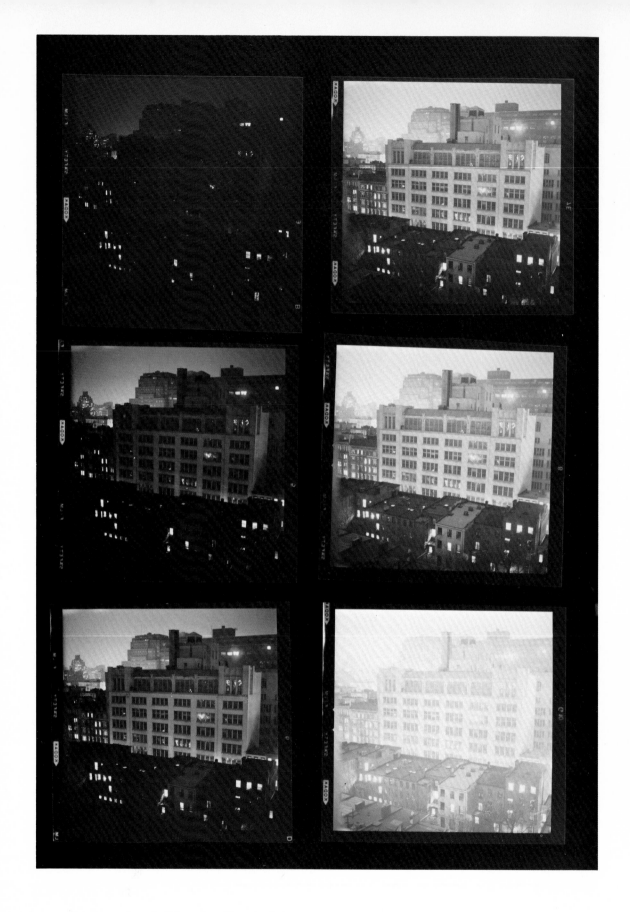

Exposure. I made this series ("bracket") in 1943 in preparation for a *Life* essay on "New York Dimout" (*Life,* Feb. 1, 1943). I wanted to find out how much detail the lens would pick up from a virtually pitch-black scene. Exposures ranged from one second to five minutes.

Exposure 1/1000 sec. The lightbulb is disastrously underexposed; only the glowing filament shows.

Exposure 1/250 sec. The outline of the bulb, together with some detail, begins to appear.

Exposure 1/100 sec. This is what I would call a "correct" exposure of the lightbulb.

Exposure 1/10 sec. The bulb is overexposed, contrast is too low, and the picture is almost uniformly gray.

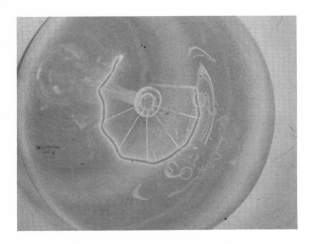

Exposure 1 second. The bulb is considerably overexposed; the filament begins to solarize.

Exposure 10 seconds. The bulb is disastrously overexposed; solarization of the filament is complete.

This lightbulb series dates back to 1932. I was curious to see how film would react to a subject of extremely high contrast. I found, to my surprise, that the first shot looks positive and the last shot looks negative, although both are positive prints.

Development
Normal

Shorter-than-normal ◄————————————————————► Longer-than-normal
(Underdevelopment) (Overdevelopment)

Shorter-than-normal
(Underexposure)

Film exposure
Correct

Longer-than-normal
(Overexposure)

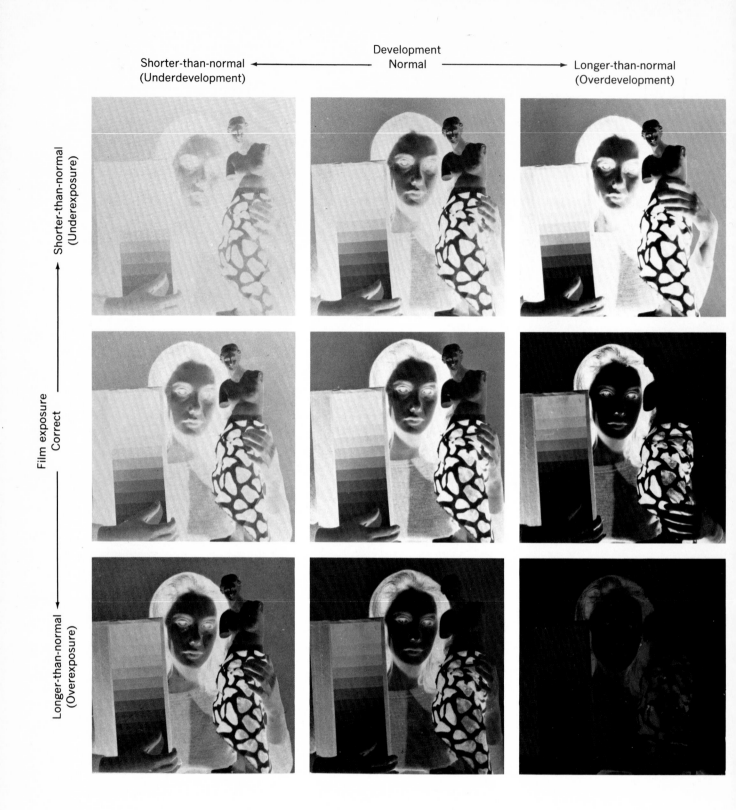

The nine negatives. Experimenting with different combinations of exposure and developing times is the first step in learning to control the density and contrast gradient of negatives. It is also a vital prerequisite for accurately diagnosing the causes of unsatisfactory negatives in order to prevent recurrences. This series illustrates the nine possible combinations of exposure and developing times and their effects. For detailed information, consult *Darkroom Techniques*, Vol. I.

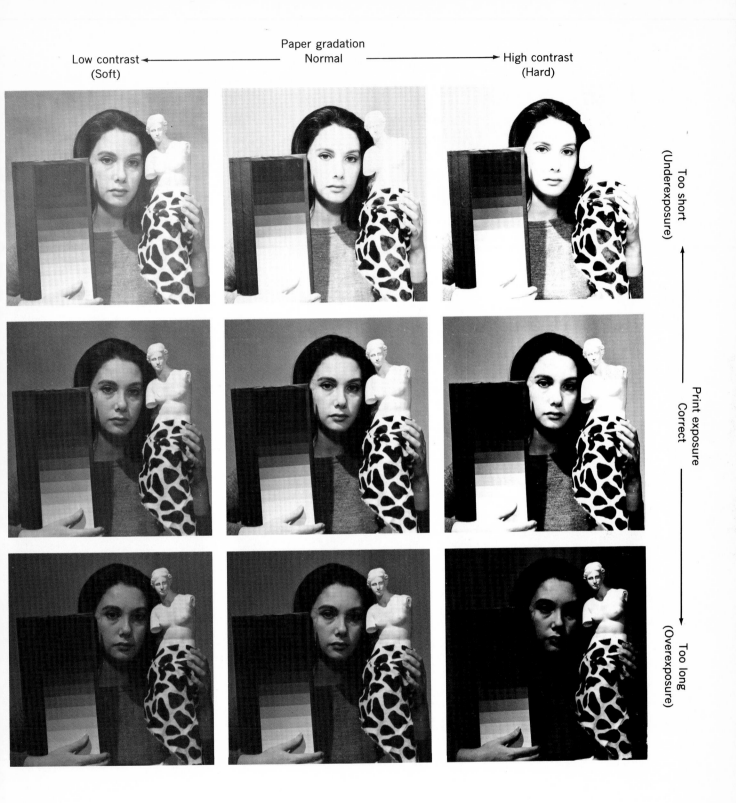

The nine positives. Experimenting with different combinations of paper gradation and print exposure times is the first step in learning to control the contrast gradient and degree of darkness of prints. It is also a vital prerequisite for accurately diagnosing the cause of unsatisfactory prints in order to do better next time. This series illustrates the nine possible combinations of paper gradation and print exposure times and their effects. For detailed information, consult *Darkroom Techniques,* Vol. II.

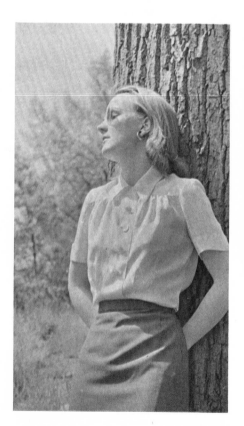

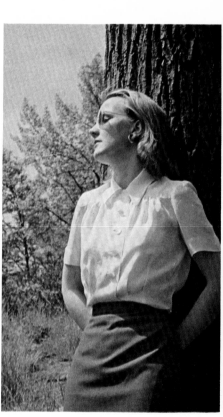

Contrast. How high is the degree of control that a photographer has over the contrast gradient of his print?

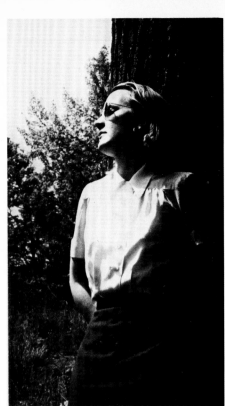

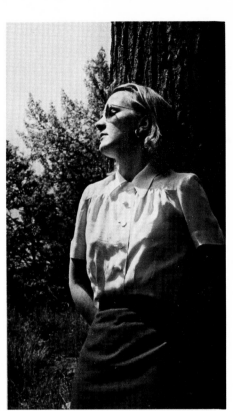

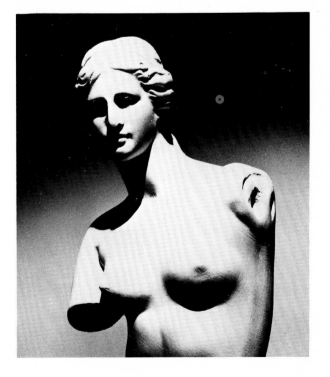

To find out, I used "all the tricks in the book" and discovered to my delight that I could vary contrast from virtually uniform gray to pure black and white, including, of course, any intermediary gradations. The means for achieving this kind of control are discussed in *The Complete Photographer* and *Darkroom Techniques.*

Color. To learn how far I could control the manner of color transformation into shades of gray, I performed, among others, the experiments shown on this spread. Here, too, a photographer who has done his "finger exercises" can transform virtually any color into any desired shade of gray, including black or white. Complete information on the respective techniques can be found in *The Complete Photographer* and *Light and Lighting in Photography*.

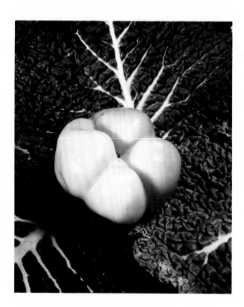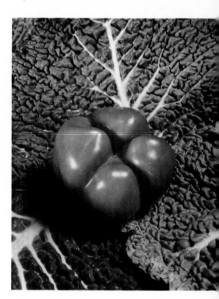

(Top row) *Control of one color: blue.* Through appropriate filtration, a blue sky can be rendered in any desired shade of gray from white to black, and clouds can be made to stand out to any desired degree.

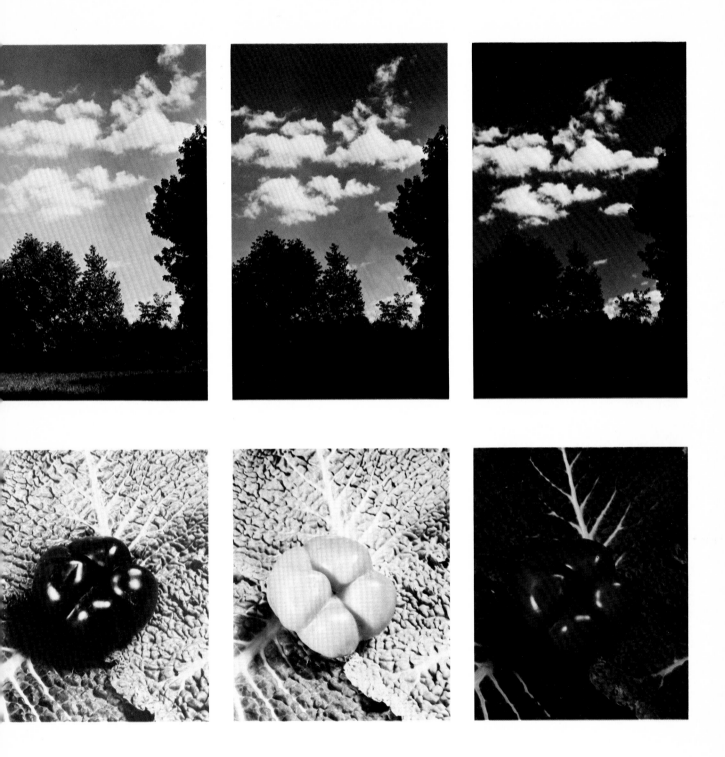

(Bottom row) *Control of two colors: red and green* (red pepper on a green cabbage leaf). Again, control is so complete that these two complementary colors can be rendered as white on black, gray on gray, black on white, white on white, black on black, or, if so desired, as any intermediary shades.

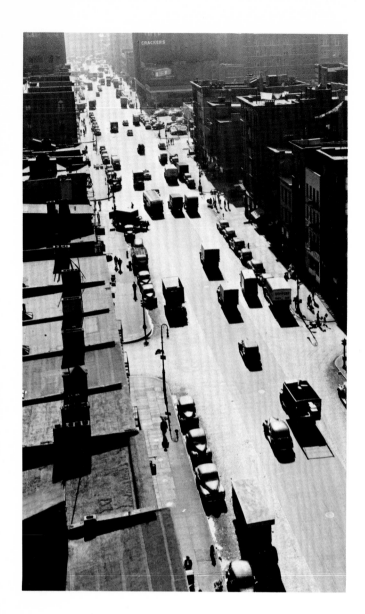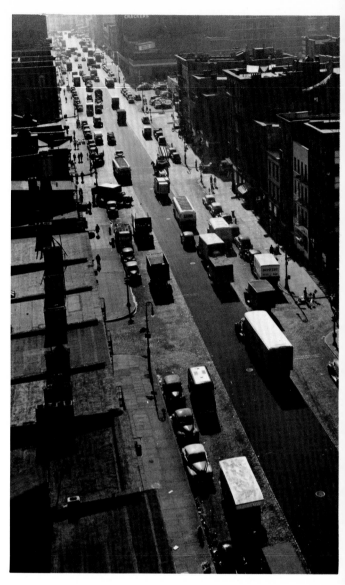

Control of glare and reflections. Through appropriate application of a polarizer, glare and reflections can be moderated to almost any desired degree, and under certain conditions they can be completely eliminated. How this can be done is explained in *Light and Lighting in Photography*. The three picture pairs shown here illustrate extremes (intermediary effects are easily achieved): The left component was taken without a polarizer, the right one with a polarizer in a position of maximum effect.

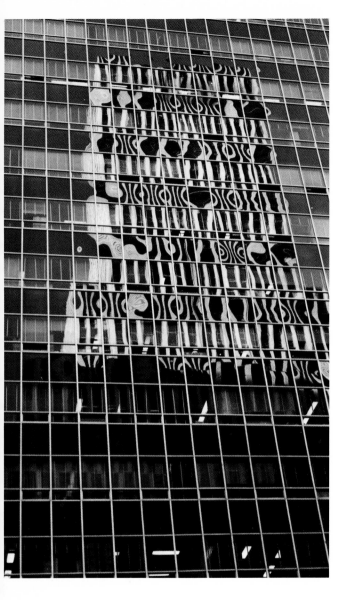

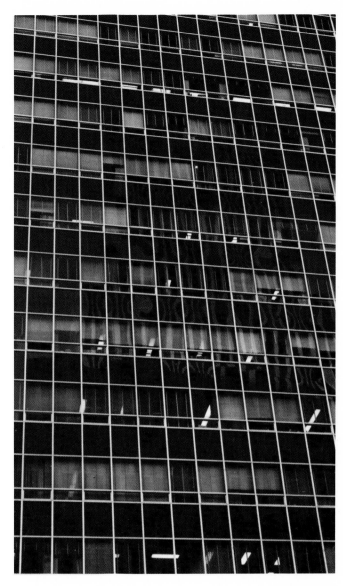

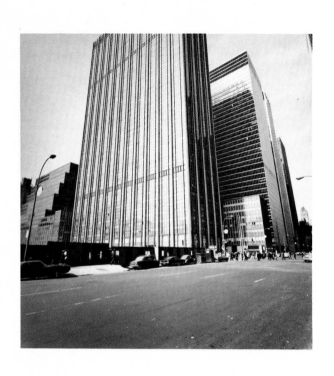

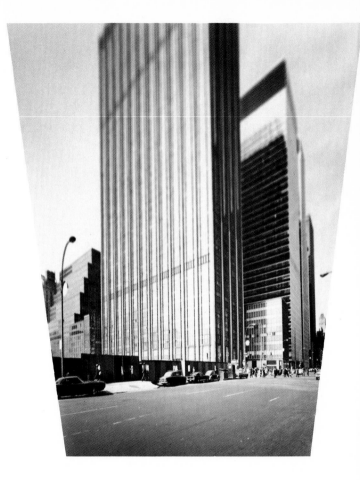

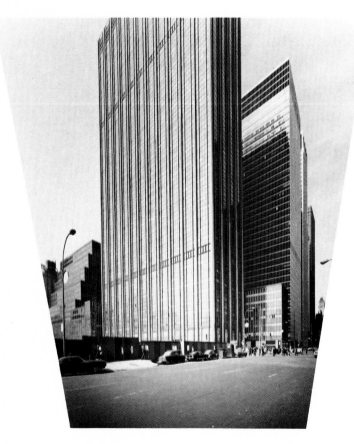

Perspective control through enlarging. To make an "undistorted" print from a negative in which verticals converge, proceed as follows:

1. Project the "distorted" negative onto the easel. The image will appear as in the picture above, left.

2. Tilt the easel until the verticals appear parallel in the projected image and support it in this position. The trapezoid-shaped image will be partly blurred as in the picture above, right.

3. Tilt the negative in the opposite direction from that in which the easel is tilted until, after appropriate refocusing, the image appears sharp in its entirety as in the picture at the left.

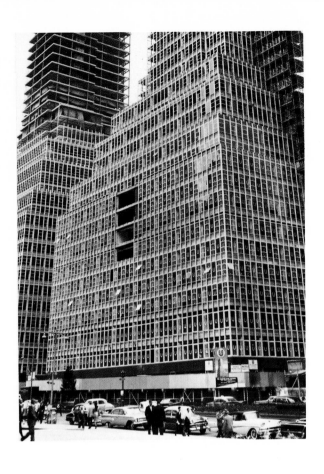

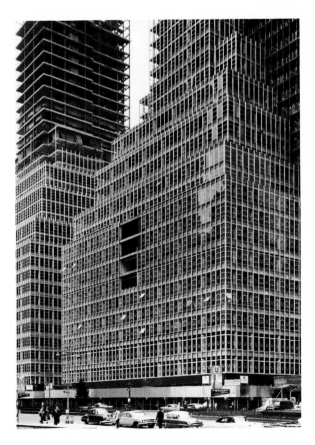

Perspective control with a view camera. To take a picture of a tall building that is free from "perspective distortion," proceed as follows:

1. Place the camera on a tripod; then aim and focus as usual. Verticals will converge on the ground glass as in the picture above.
2. Level the camera. In this position, verticals will appear parallel on the ground glass, but the upper part of the building will be cut off as in the picture above, right.
3. Raise the lens until the upper part of the building appears on the ground glass as desired, stop down the diaphragm, and make the shot. The building will appear at its full height, its vertical lines parallel.

1

2

Space control. The four types of photographic perspective. Human vision perceives "space" in only one way; the camera offers a choice of four. To explore their characteristics, I photographed the same subject four times with different lenses.

1. *Academic rectilinear perspective.* This is the way most people perceive space: Straight lines appear straight, and verticals appear parallel. This is a static form of space rendition, easily achieved with any swing-equipped, view-type camera (p. 29) or with the aid of an enlarger (p. 28) in case the negative is "distorted." This shot was made with a lens of standard focal length.

2. *True rectilinear perspective.* This is the way things "really" are: *All* parallel lines that recede from the observer (or the camera) appear to converge toward vanishing points, regardless of whether they are horizontals or verticals. This is a dynamic form of space rendition characterized by "converging verticals"—the type of perspective we automatically get if we don't hold the camera perfectly level. This shot was made with a wide-angle lens with the camera pointed slightly upward.

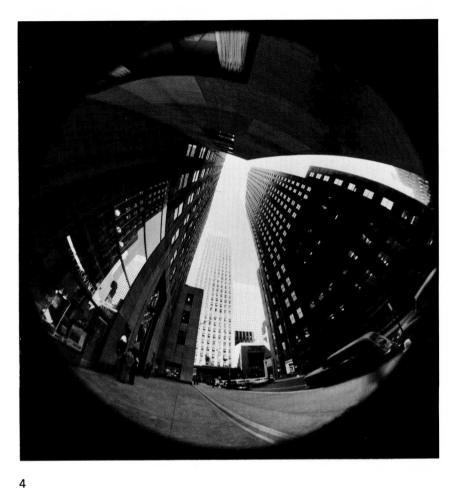

3 4

3. *Cylindrical perspective.* Verticals, although actually straight, appear as curves. This form of perspective is even truer to reality than form no. 2 because it eliminates the unnatural acute angle between the vertical lines and the level ground. This shot was made with a panoramic camera, the lens of which prescribes an arc during the exposure.

4. *Spherical perspective.* This form of perspective, although a geometrically correct projection of reality, appears "unnatural" to most people because it includes the enormous angle of view of 180 degrees or more within a single picture. However, since it is a form of "super-vision" that vastly exceeds our inherent visual capability, I feel we should not consider it "unnatural," as a "distortion" of reality, but should use it similarly to the way we use a microscope, or a vise, or an airplane—to overcome, as much as possible, specific congenital limitations. We should familiarize ourselves with its characteristics, learn to "read" such photographs correctly, and use this form of perspective in cases in which more conventional forms would be inadequate. This shot was made with a fish-eye lens.

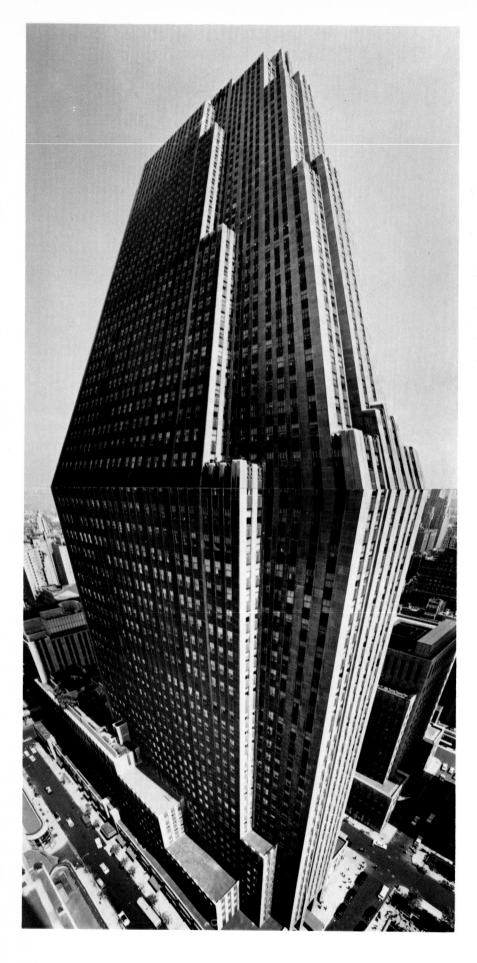

Synthesis of a cylindrical perspective. From top to bottom, the view of the building on the opposite page, which was made with a panoramic camera scanning vertically, includes an angle of view of 140 degrees. This is twice the 70-degree angle of view that a wide-angle lens encompasses, which is already quite a respectable angle. (For comparison, most standard lenses include an angle of about 45 degrees.) To prove to myself why, in such an extreme view, the vertical sides of the building *must* appear to bulge, I made the picture at the left. It is a composite of two photographs, each made with a wide-angle lens encompassing an angle of 70 degrees. One shot was made with the camera tilted upward, the other with the camera angled downward. Naturally, the verticals—here, receding parallels—appear to converge toward vanishing points in the direction of the top and bottom of the picture. But the break at the center is completely unnatural. This objectionable break is avoided in the view at the right, where the transition from far (top) to near (middle) to far again (bottom) is graphically expressed in the form of smooth and elegant curves. Having satisfied myself in this way of the necessity for "curving verticals" in extreme wide-angle shots, I find such views no longer unnatural, but can now enjoy them as manifestations of a form of seeing that is beyond the capability of my unaided eyes. Such views widen my awareness of space.

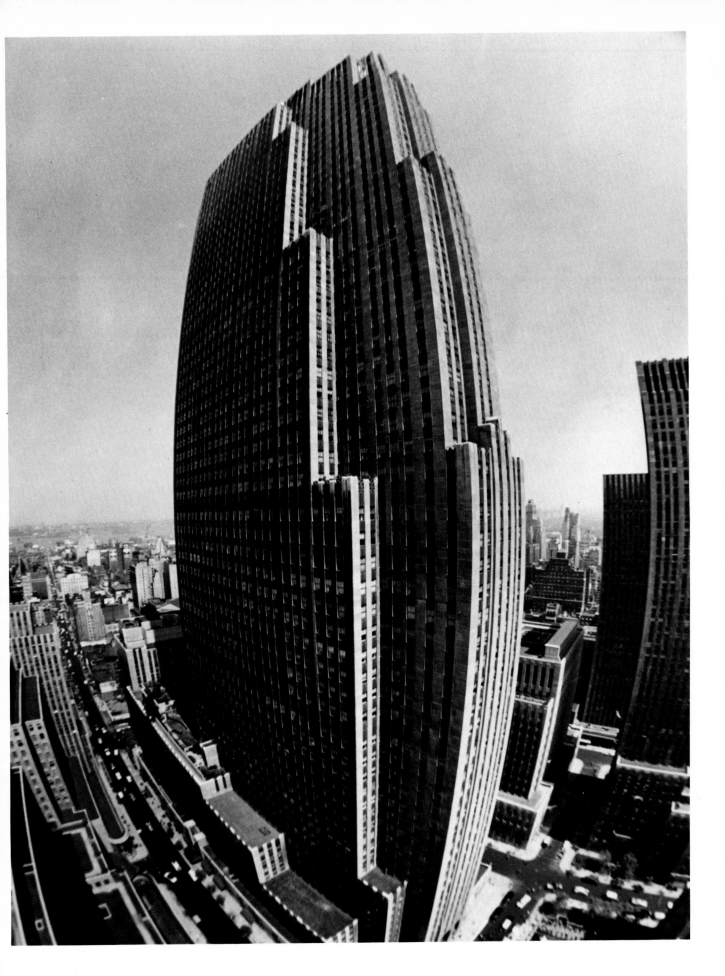

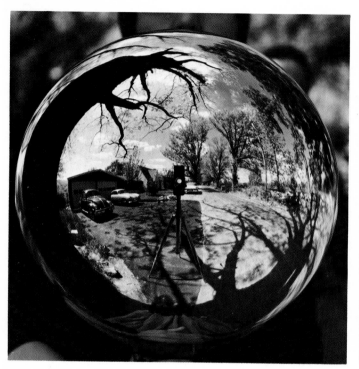 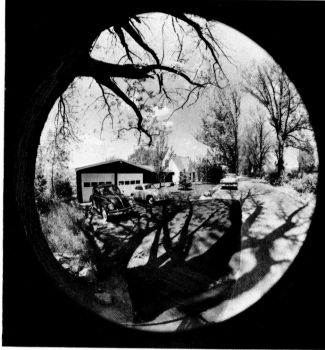

Synthesis of a spherical perspective. At first glance, the two photographs above seem to be identical. However, upon closer examination, one will see that the camera and tripod in the center of the left picture are missing in the shot at the right. This is the clue that proves that the left photograph shows the scene reflected in a mirrored sphere, while the other picture was made from the position of the sphere using a camera equipped with a fish-eye lens.

What I wanted to prove with this experiment is that, as far as "perspective" is concerned, the image produced by a fish-eye lens is identical to the image of the respective subject or scene as it would appear reflected in a mirrored sphere. In other words, it is not something "artificially distorted," but a special form of projection following rigid natural laws. If such a rendition seems "unnatural" to us, the fault is ours, not that of the lens. This kind of perspective rendition is simply a form that, being beyond our inherent visual capability, is still new to us. But increasing familiarity should soon bring anyone to the point where he will see nothing strange in the view on the opposite page, but only an interesting 180-degree panorama of Rockefeller Center in New York City.

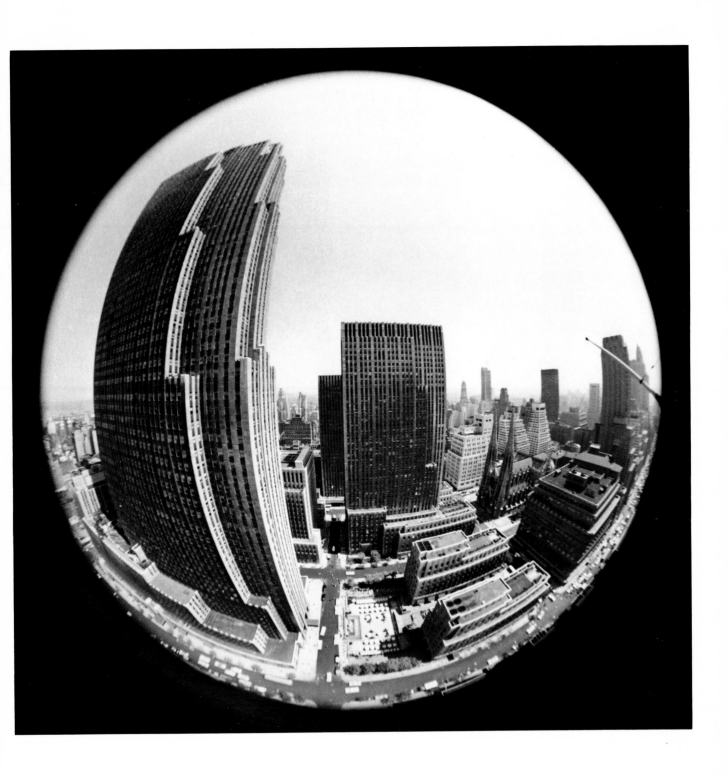

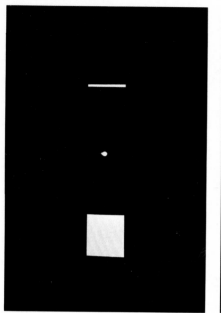 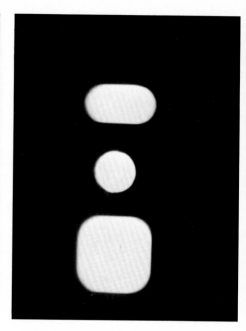

To me, there is a strong psychological difference between "white" and "light." In a photograph, however, "light"—a light source—can normally be rendered only as a blob of white, leaving such a picture, as far as I am concerned, inferior to the actual experience. To remedy this and to find better graphic forms of rendering "light," I experimented with various light symbols —unsharpness (above), diaphragm stars (below), and stars created with the aid of various screens (opposite page).

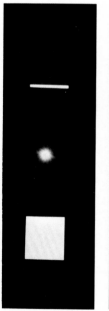 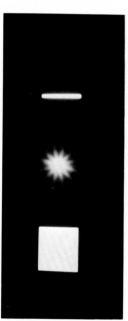 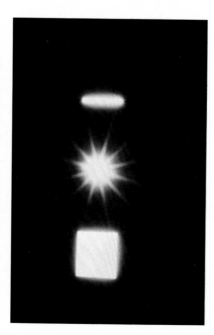 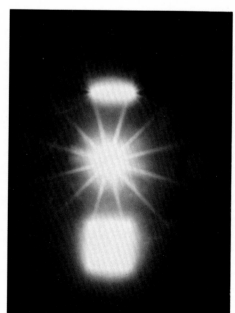

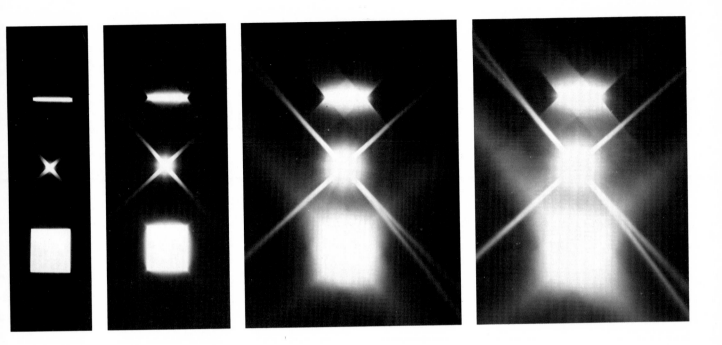

This I did by cutting three forms—a line, a tiny circle, and a square—out of thin black cardboard (the first picture, top left), placing a light source behind this mask, and photographing it in transmitted light with different techniques. Some of the results are shown on this spread. In every case, the particular effect increases proportionally to increases in exposure. Detailed information on these processes can be found in *Light and Lighting in Photography* and *Total Picture Control.*

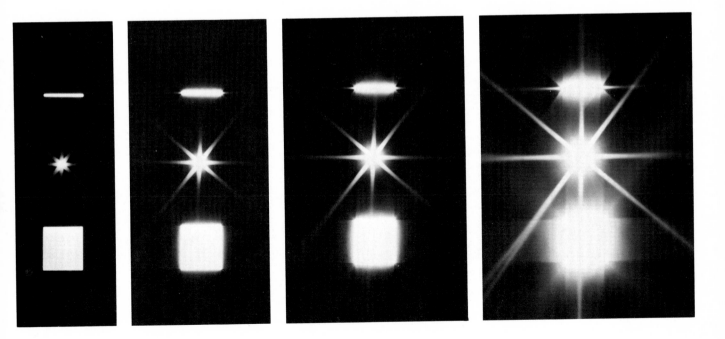

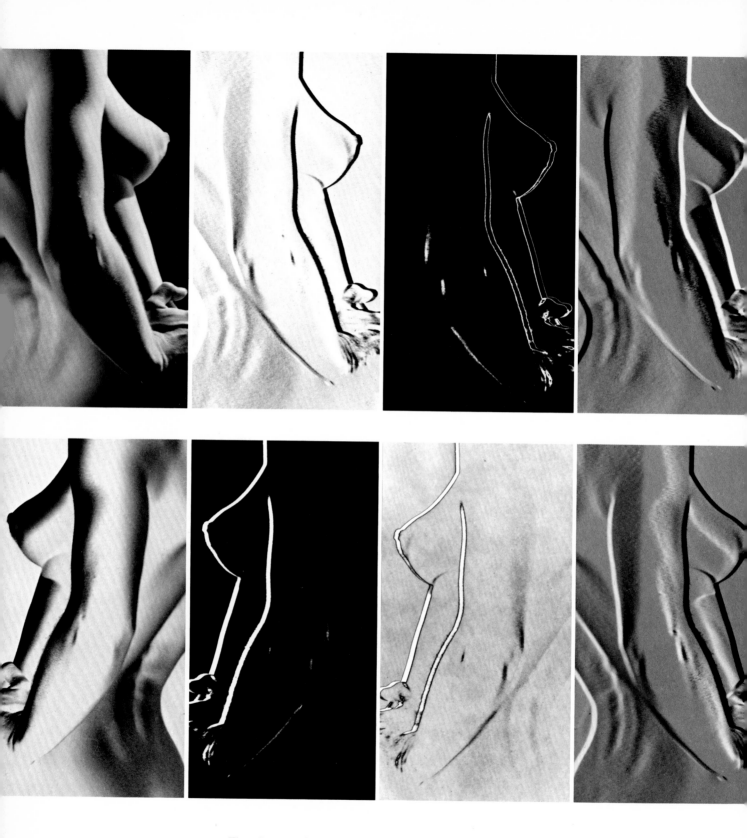

The photographic control processes. To explore their possibilities, I systematically applied all the different techniques and their combinations to one and the same negative: solarization, reticulation, the bas-relief process, and reversion into the negative form. In all, I produced some

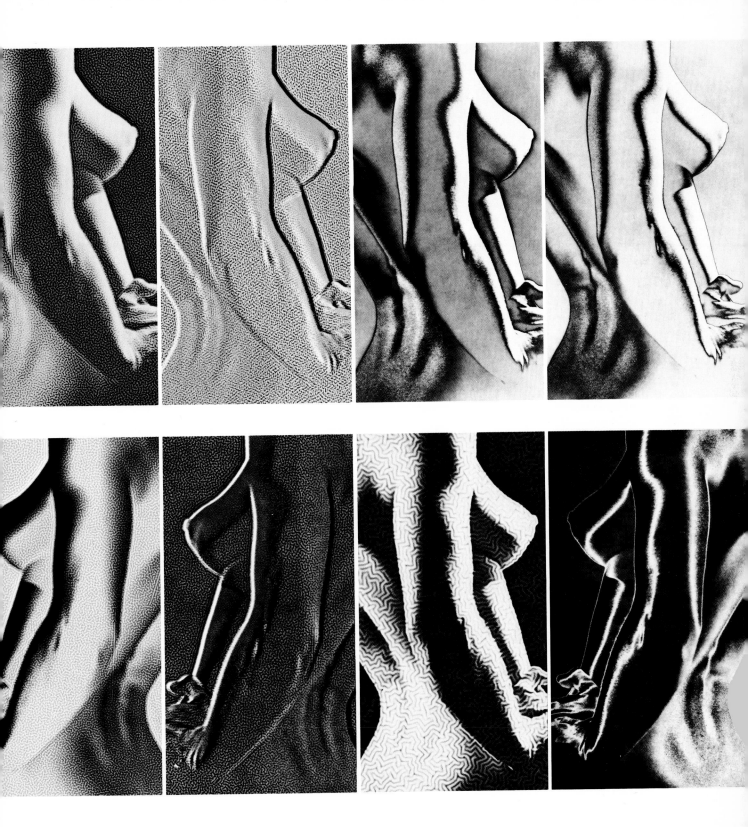

50 different prints, quite a few of which, of course, were of technical interest, but were esthetically unsatisfactory. Sixteen of the more interesting ones are shown on this spread. Readers interested in these techniques can find relevant information in *Darkroom Techniques,* Vol. II.

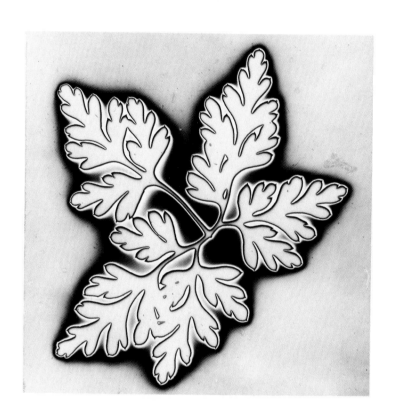

Experimental Work, 1928–1976

Knowledge into Performance

The following pages contain photographs illustrating how knowledge gained from experimentation can be used to create images that show familiar subjects in forms different from those to which we have been accustomed. However, I used this difference in subject approach and rendition *not* in the sense of a gimmick or trick—merely as an attention grabber or as novelty for novelty's sake—*but* because I had come to the conclusion that, in every case, the chosen form of presentation would be superior to a conventional one— more expressive, more likely to bring out the essence of the subject, to interest and stimulate the viewer and thereby give him something he hadn't seen or felt or thought before.

To qualify for inclusion in this collection, each photograph had to show the subject in a form that was *significantly* different from what the unaided eye would have seen in reality. Notice the emphasis on "significance," by which I mean that the "difference" must be rooted in a form of presentation that is "superior" to a conventional one. It is "superior" because it gives more: It communicates an aspect that a traditional rendition could not have communicated at all, or as well. In this connection, the nature of this difference is immaterial. It could be an unusual form of perspective (as in a super-telephoto or a fish-eye shot); an unusually high degree of contrast verging on pure black and white; a simplification or abstraction by means of solarization, reticulation, or the bas-relief process; an extreme form of close-up that shows the subject several times its natural size; an unfamiliar arrangement as in the case of the sea shells shown on pp. 106–109; and so on. What mattered was that the photograph was unusual enough to jolt the viewer out of his complacency; then, his curiosity aroused and attention assured, he would be rewarded with a valid visual, intellectual, or emotional experience. How well I succeeded only the reader can decide.

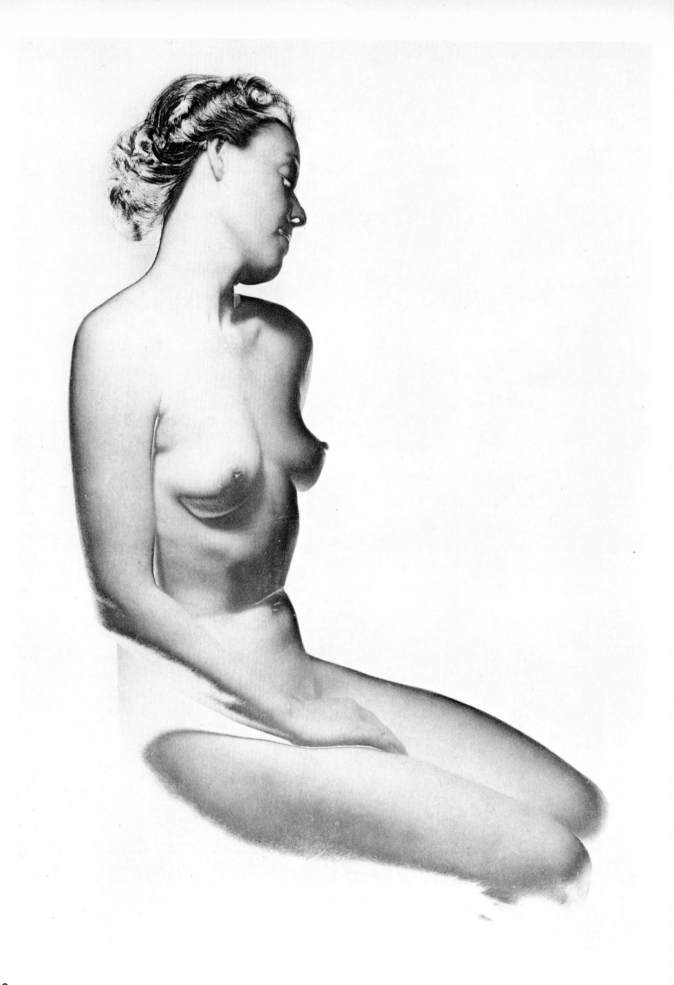

42

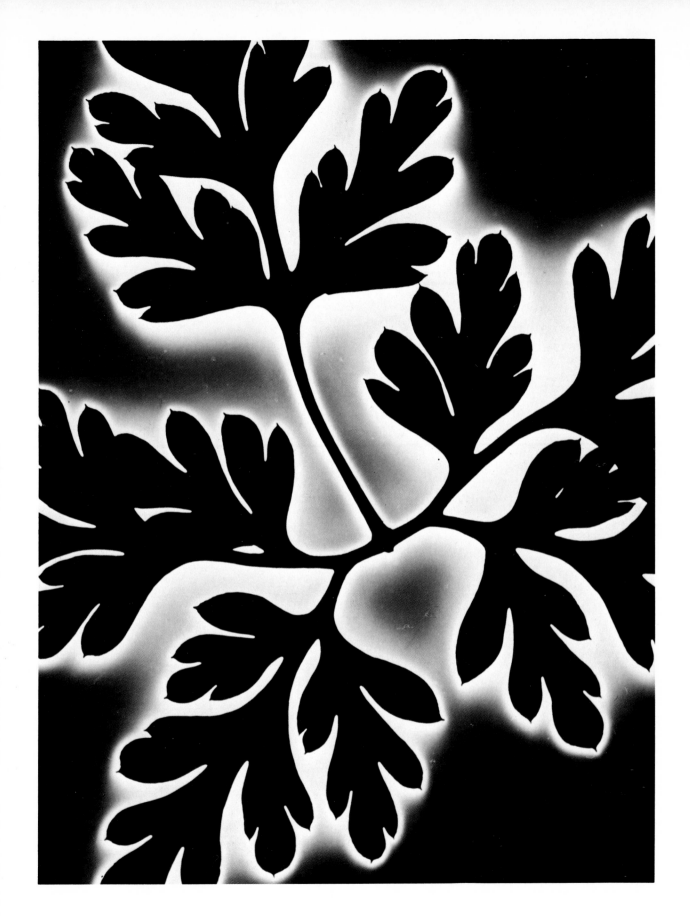

The graphic control processes, 1928–1940. I made these two solarizations in 1934. My intent was to show the beauty of these forms in the most graphically effective manner.

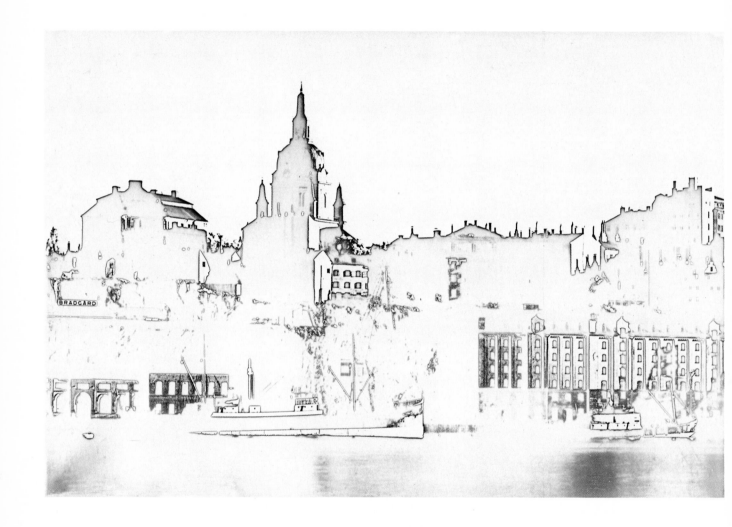

As I explained in the introduction, it was the accidental discovery of the process of solarization (more accurately, the Sabattier effect) that opened my eyes to the creative potential of photography. Stimulated by the pleasing effects of my earliest results, I avidly began to experiment to learn how to control this "new" process and produce predictable results. I soon found out that the simpler the outline and the higher the contrast of a subject, the greater the likelihood for success. These two solarizations—the left one showing the skyline of Södermalm, a borough of Stockholm —were made in 1934.

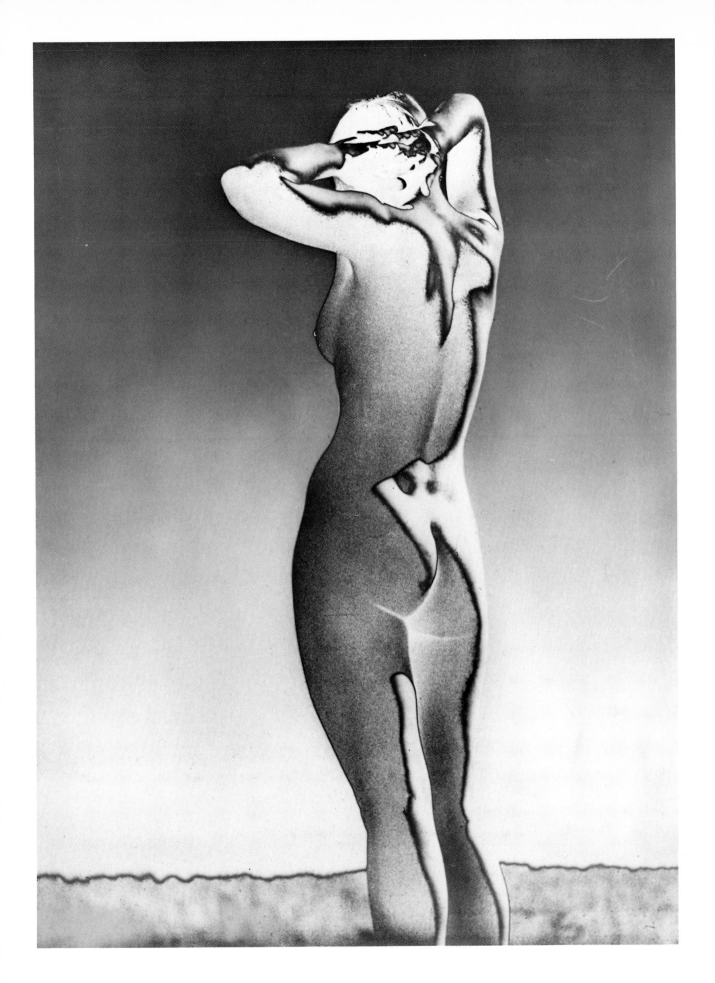

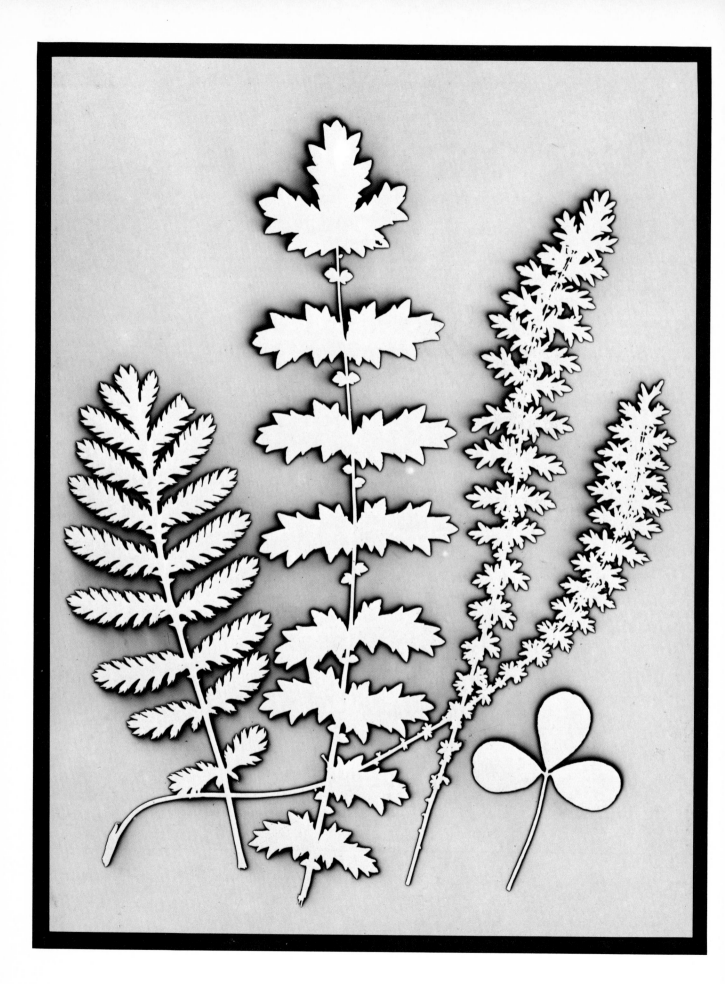

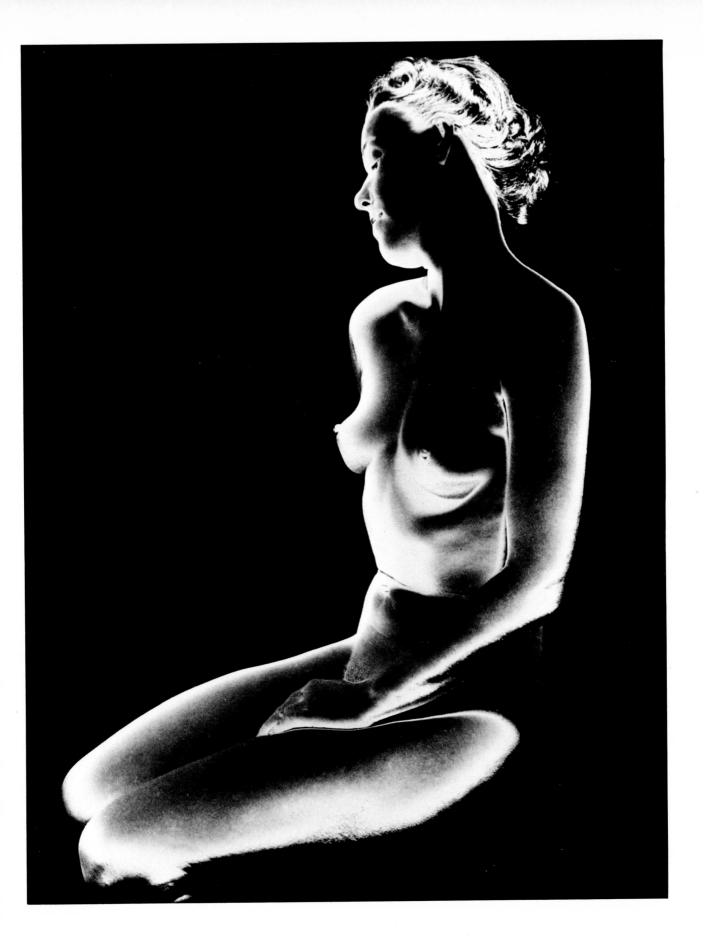

Two solarizations made in 1934. The one above was derived from the same negative as the one on p. 42.

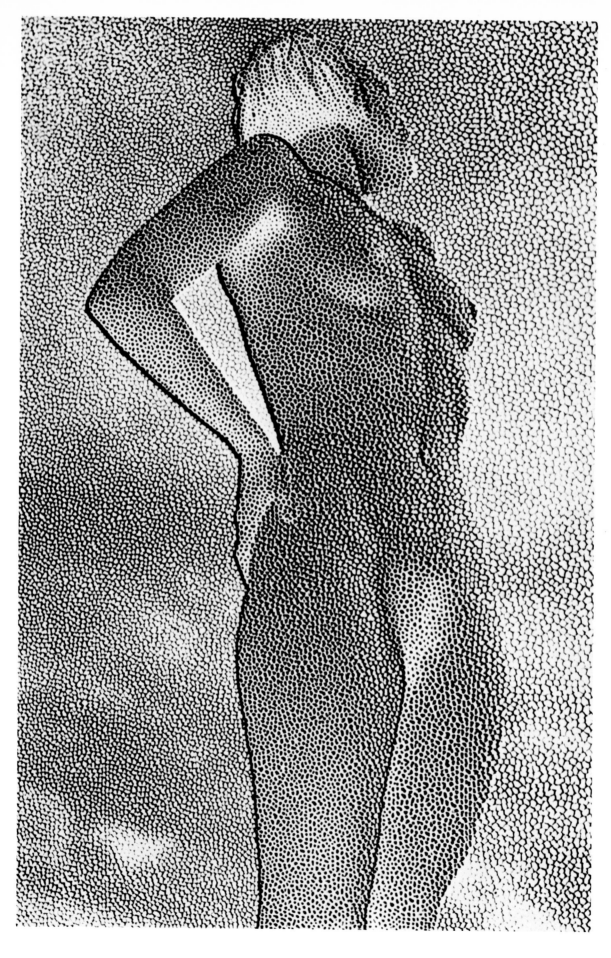

Two bas-reliefs created by enlarging a "sandwich" consisting of a negative and its reticulated diapositive taped together slightly out of register. Both were made in 1934.

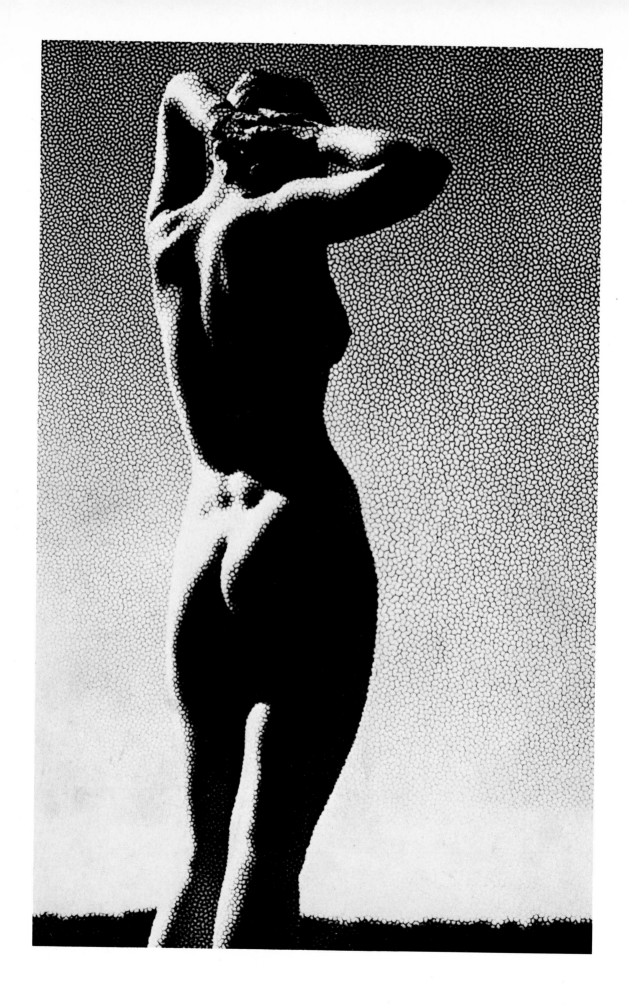

50

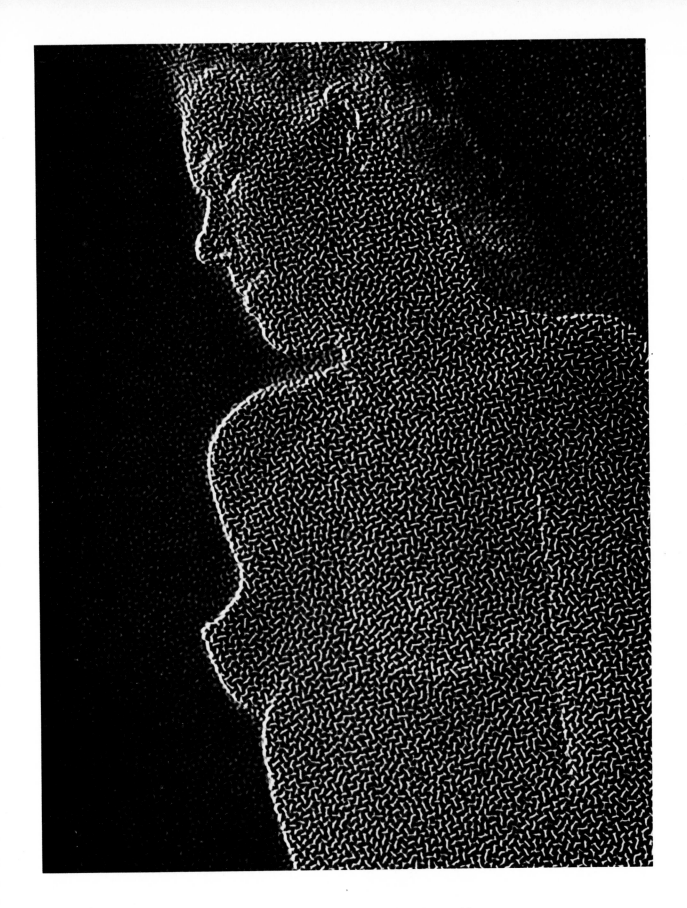

On the left is a reticulation derived from the same negative as the picture on p. 45.
Above is a reticulated bas-relief printed as a negative. This image was produced from
the same negative as those on pp. 42 and 47. All were made in 1934.

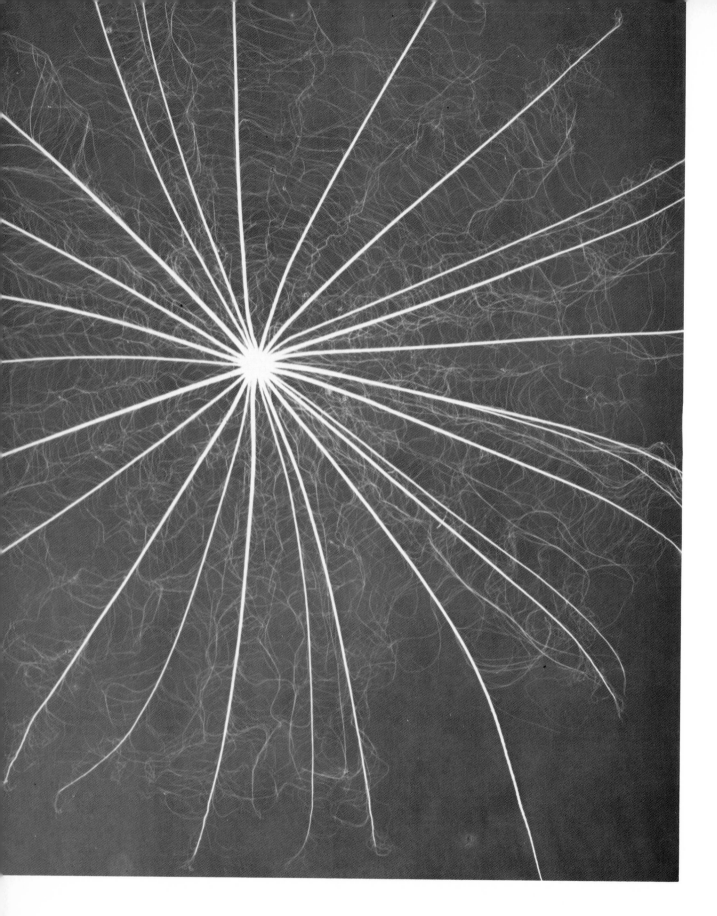

Above: direct projection of a seed by means of an enlarger (1935). Opposite page: solarized nude, New York (1940). Another version made from the same negative is shown on p. 55.

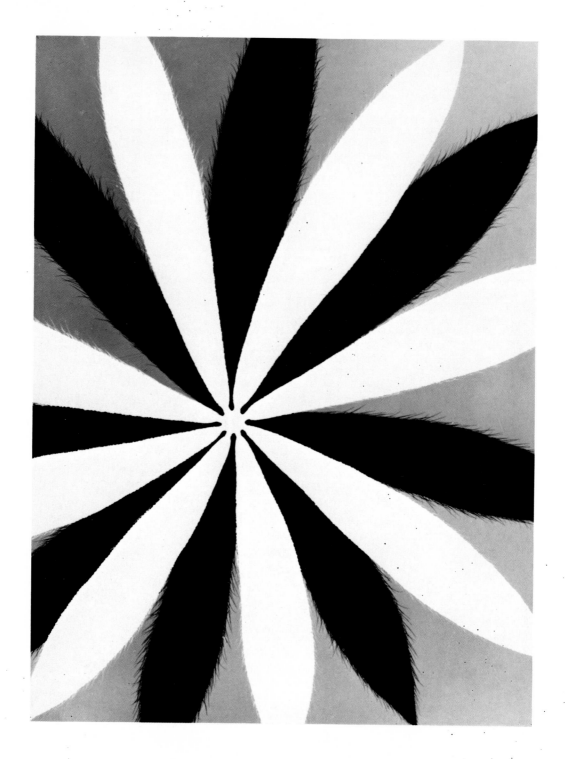

Above: negative and diapositive of the same direct projection of a leaf taped together, one rotated against the other and printed on contrasty paper (1935). Opposite page: solarization (1940) derived from the same negative as that shown on p. 53.

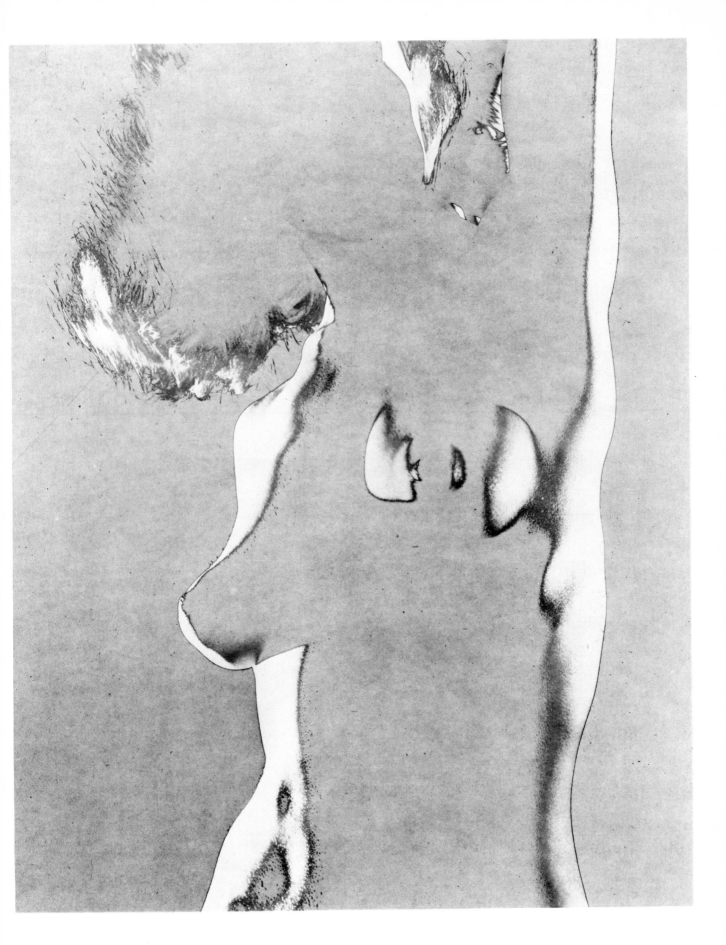

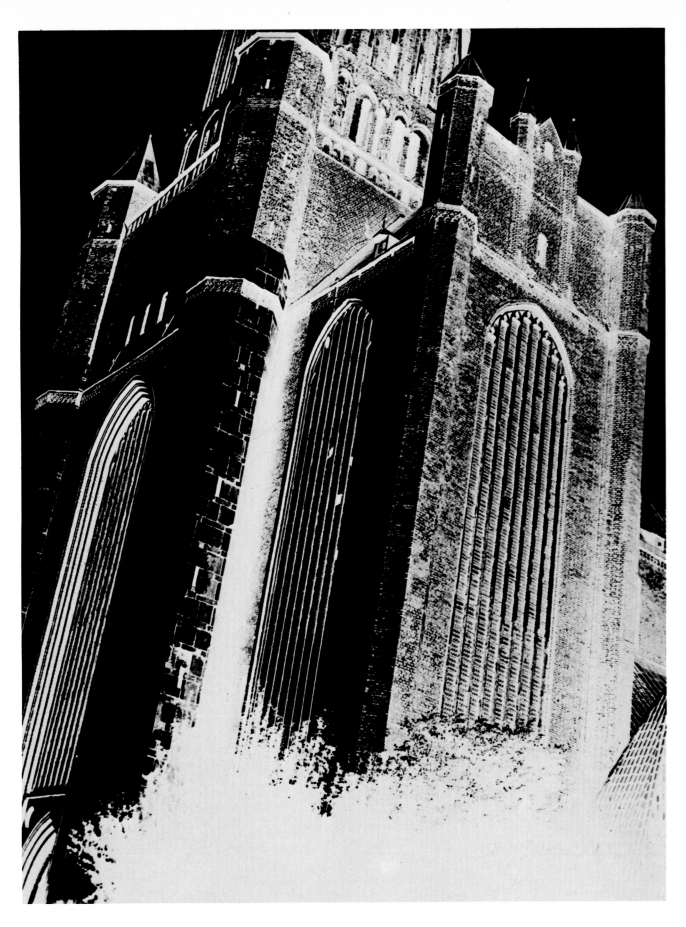

Left: bas-relief, Lübeck, Germany (1928). Above: negative print, Stralsund, Germany (1928).

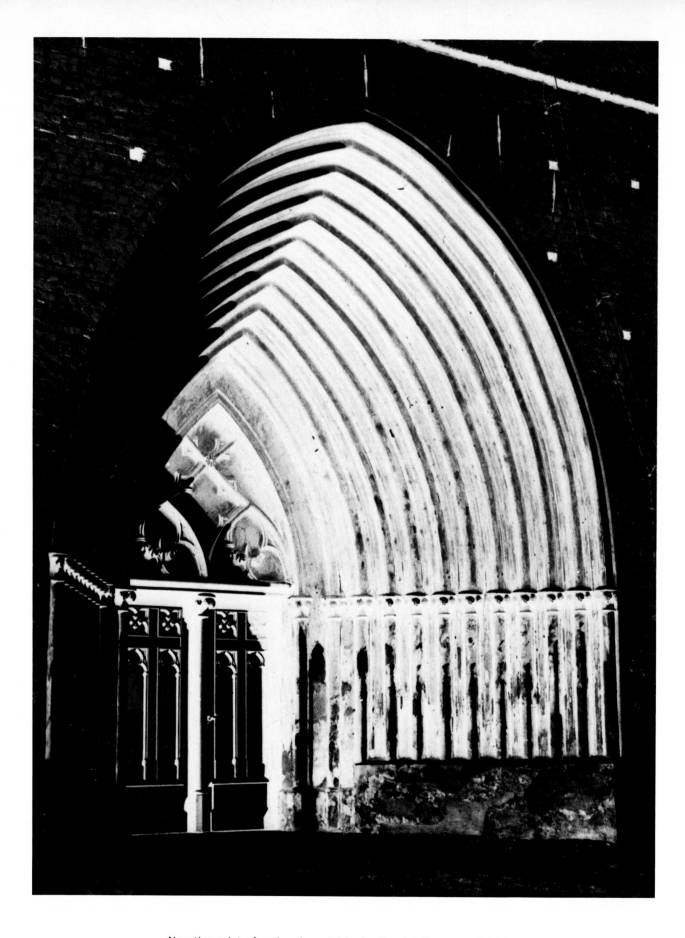

Negative print of a church portal in Greifswald, Germany (1928).

Negative print of a paddle wheeler on the Elbe near Dresden, Germany (1928).

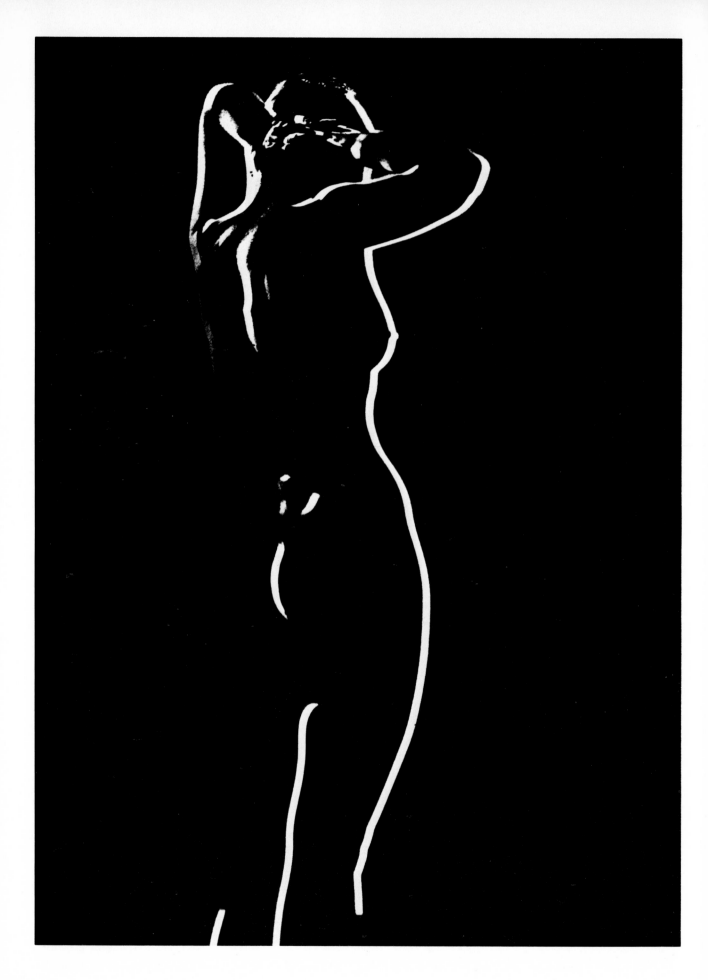

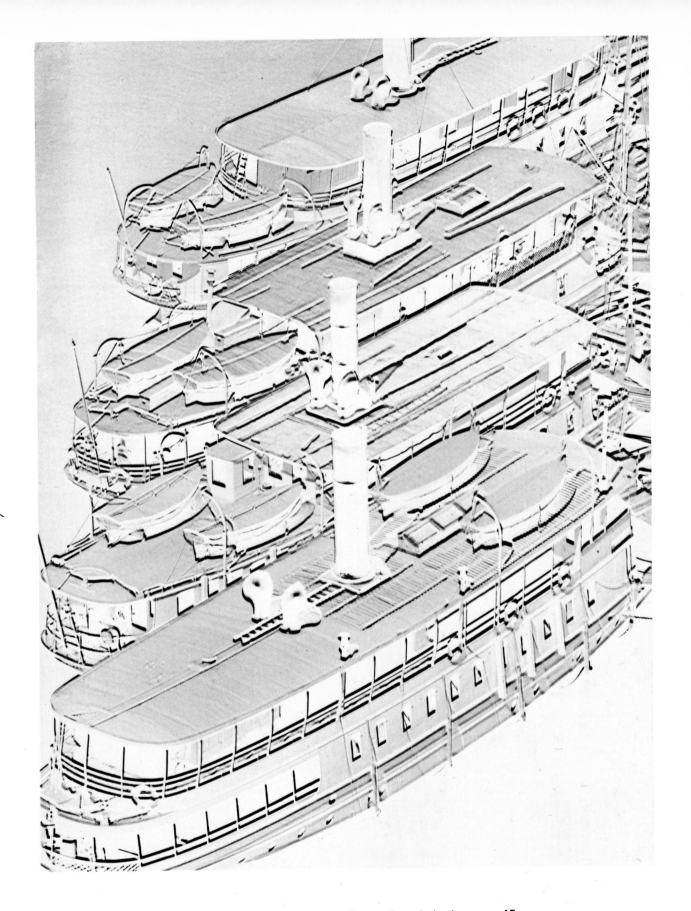

Left: negative bas-relief print derived from the same negative as the solarization on p. 45.
Above: bas-relief of lake steamers on Mälaren, Stockholm (1936). Compare with the conventional print on p. 76.

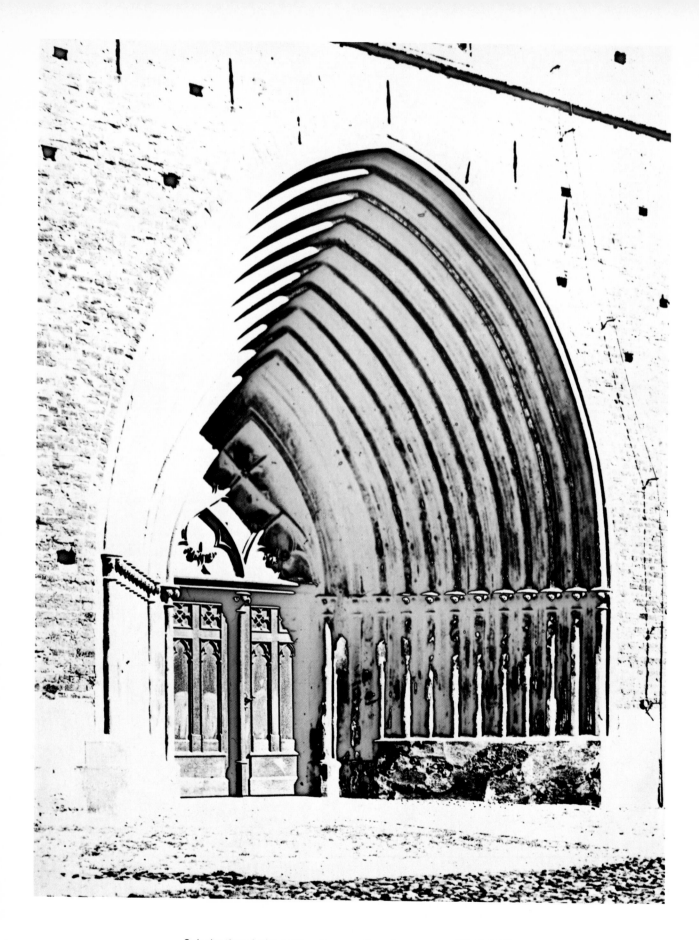

Solarization derived from the negative shown on p. 58 (1928).

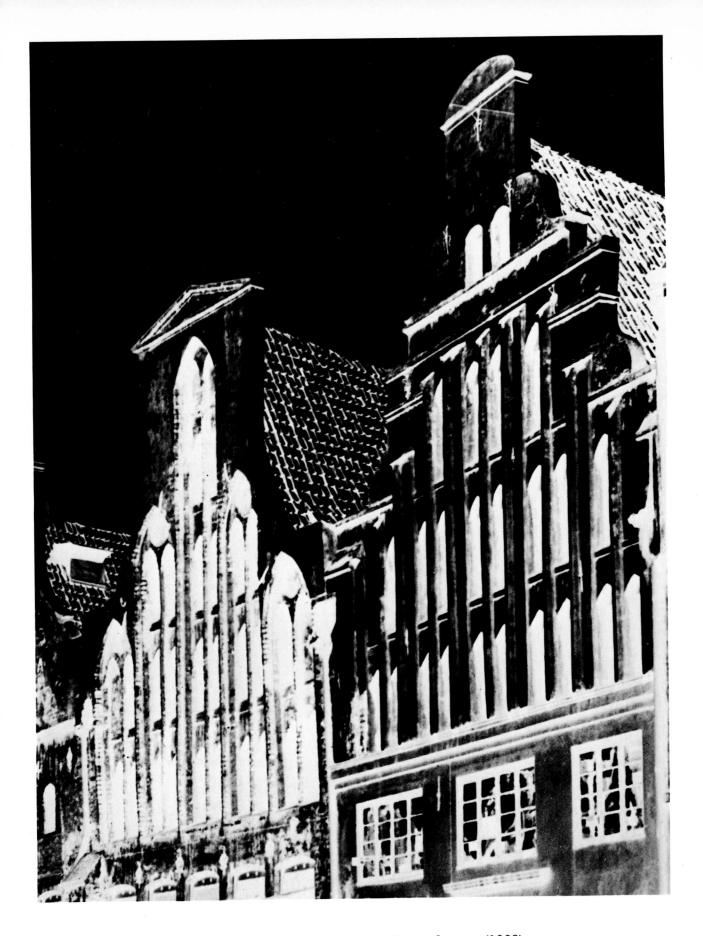

Negative print of medieval gables in Wismar, Germany (1928).

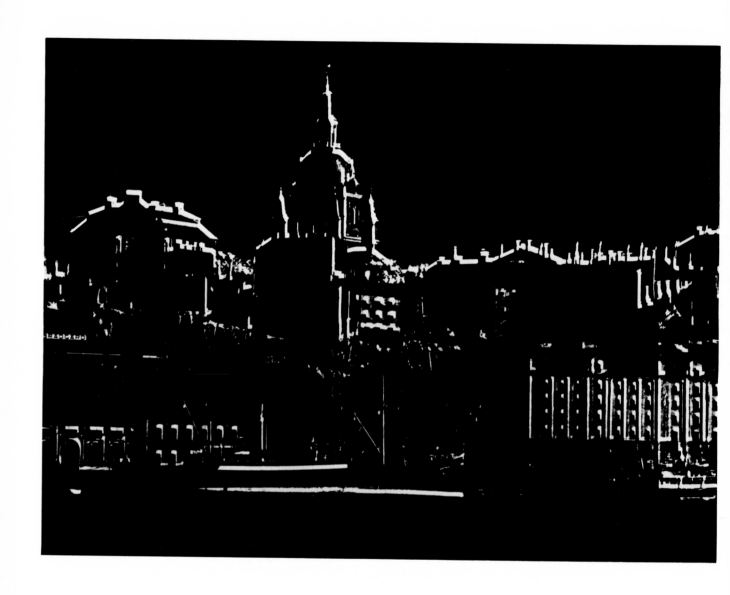

Bas-relief, negative print on contrasty paper derived from the same
negative as the solarization on p. 44 (1934).

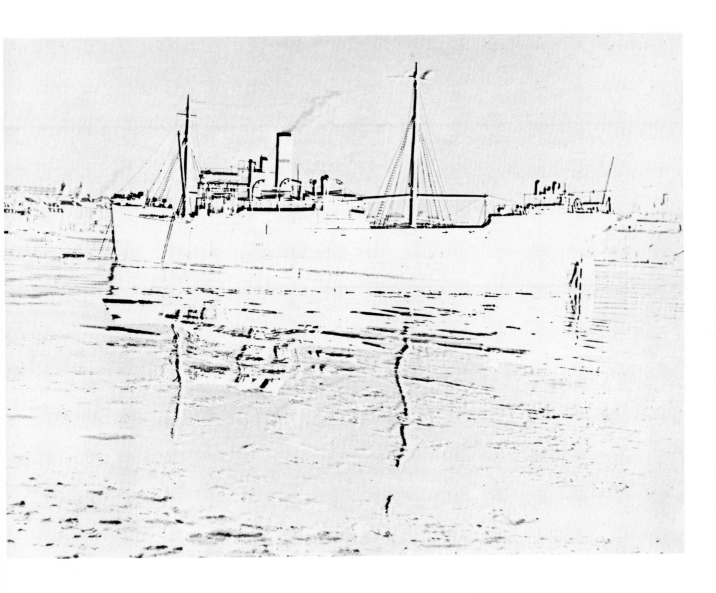

Bas-relief of freighter outside Stockholm. The print was made on extra-hard paper to achieve a pure black-and-white effect (1934).

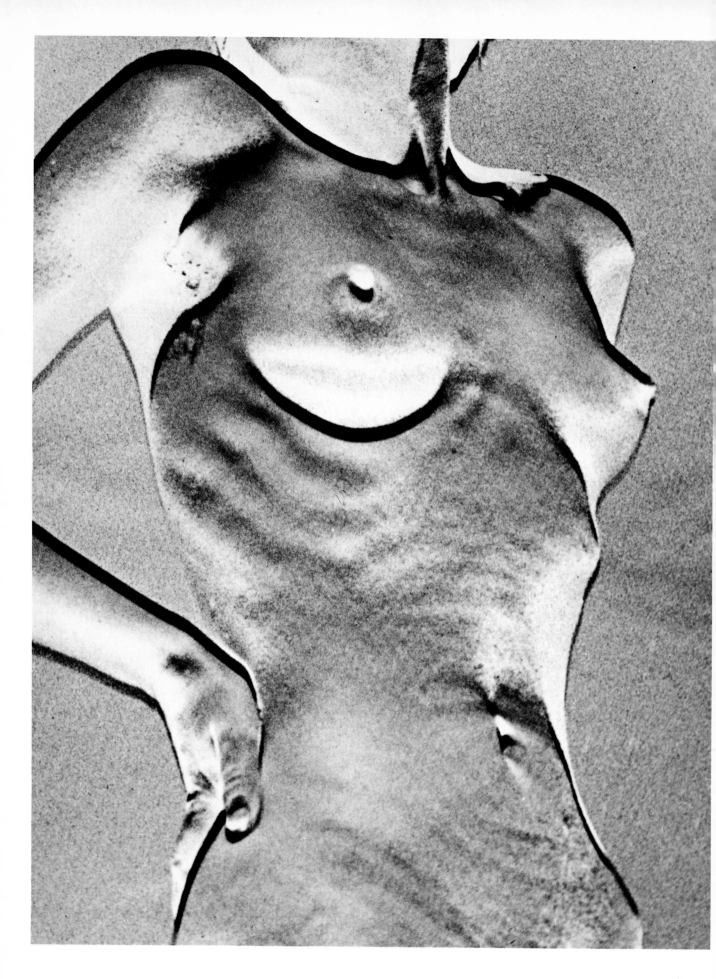

Two bas-relief prints made in 1932.

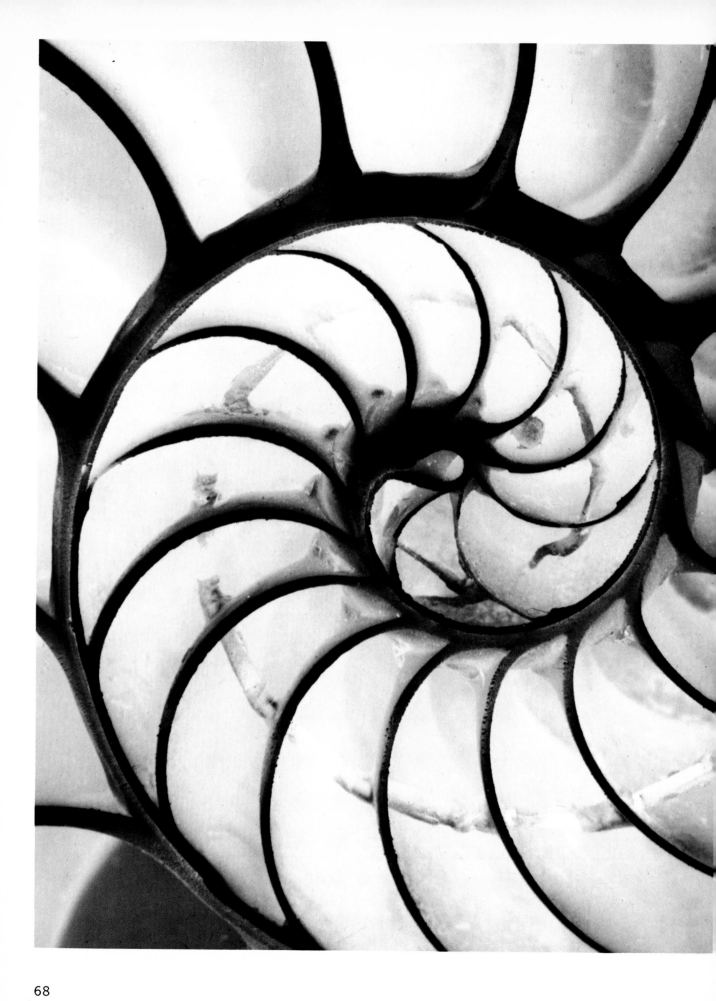

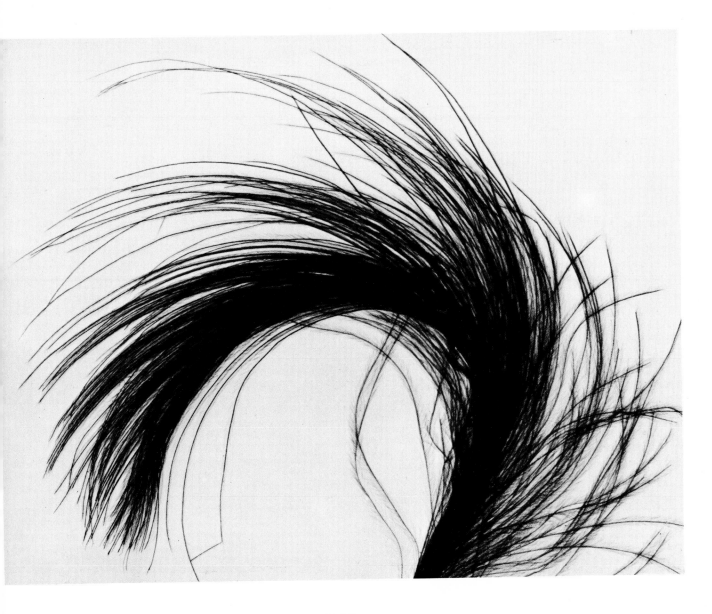

Above: direct projection of a feather (c. 1936).
Left: negative print of a sectioned nautilus shell (c. 1970).

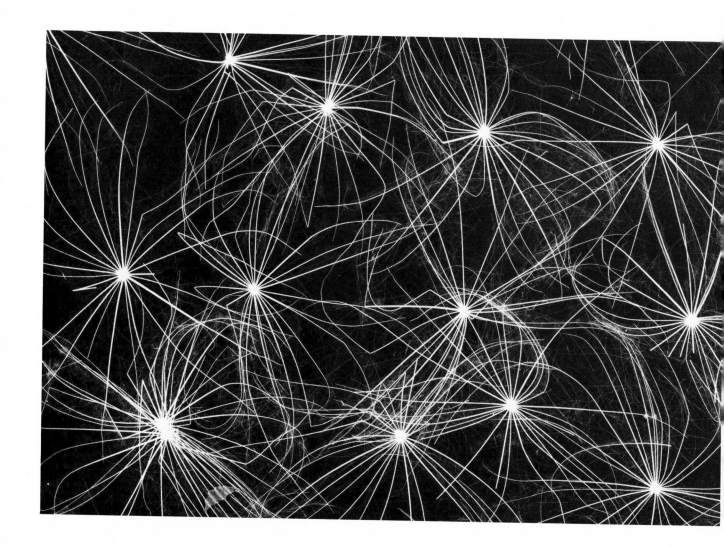

Above: direct projection of Swedish dandelion seeds. Opposite page: direct projection on paper of an oak leaf. Both images were made in 1936. Conventional photography would not have enabled me to show these beautiful structures with the same degree of precision, because elimination of the intermediary step of a negative (with its unavoidable grain) also eliminated a source of image degradation, an advantage that is clearly visible in the original prints but is lost in the screen pattern of the reproduction.

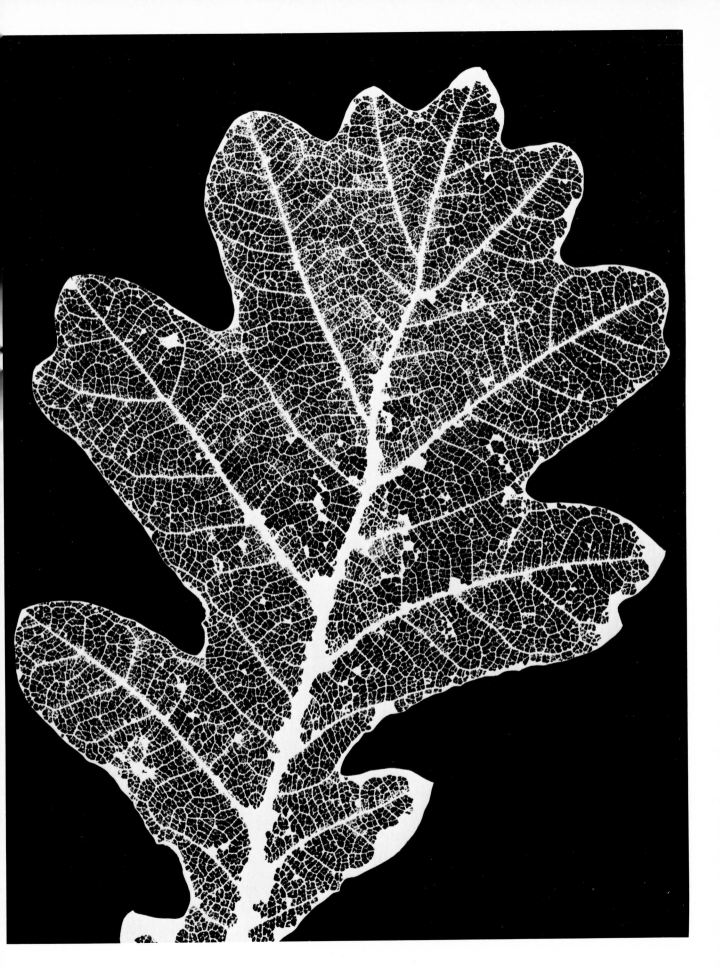

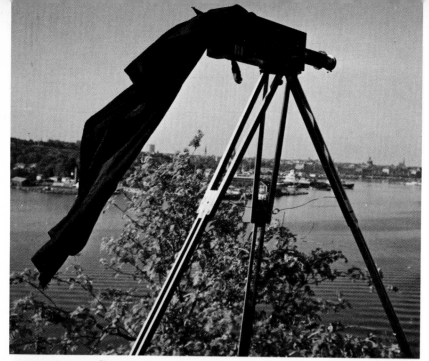

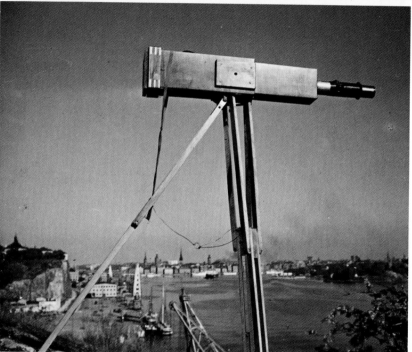

Extreme telephotography. Left: the homemade super-telephoto camera described in the introduction, on location outside Stockholm, with a view of the city in the background. The thick rubber band between the camera back and the tripod served to dampen vibration. The picture of the tourist liner *Kungsholm* on the opposite page was made in 1934 with this super-telephoto camera from the position described above. A similar ship, but black in color, can clearly be seen in the center of the middle photograph, giving a good idea of the distance from which the shot at the right was made.

It was primarily the monumentality of the typical telephoto perspective that compelled me to create my super-telephotographs—the truthfulness of this form of rendition that shows all the picture elements in nearly actual proportion to one another, with minimum "distortion" in regard to apparent size due to perspective diminution.

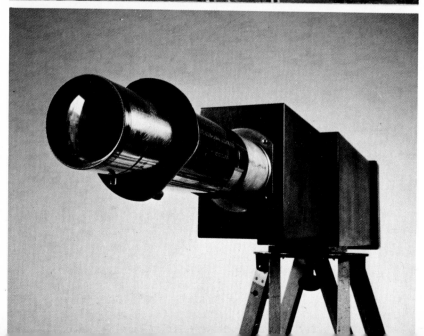

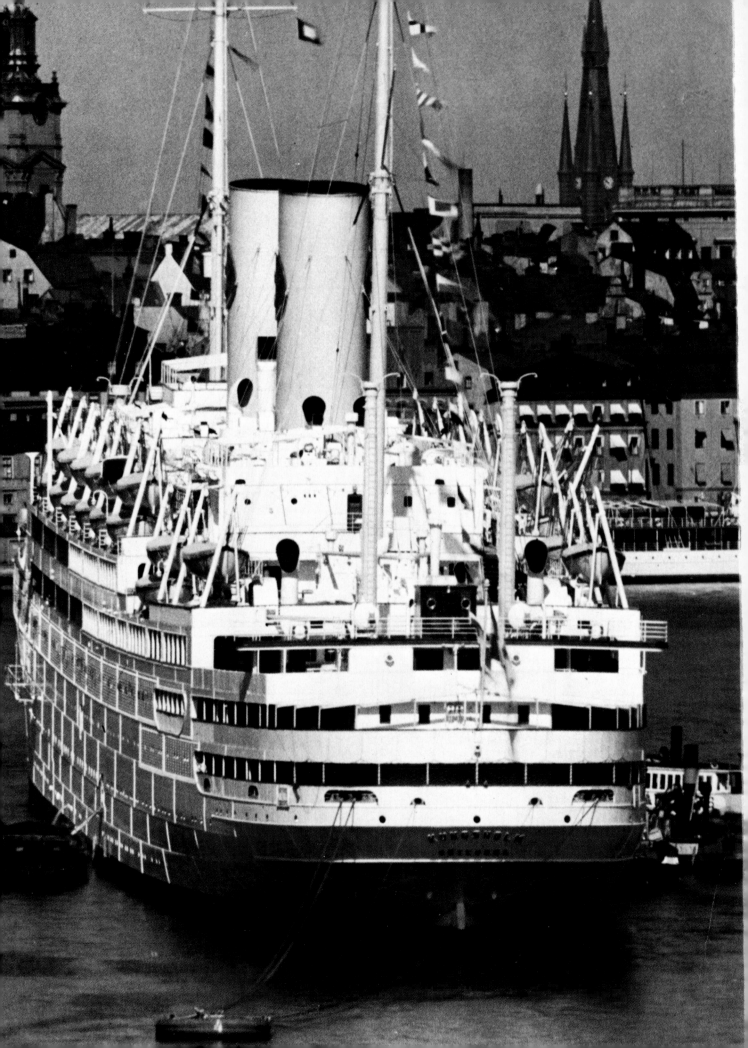

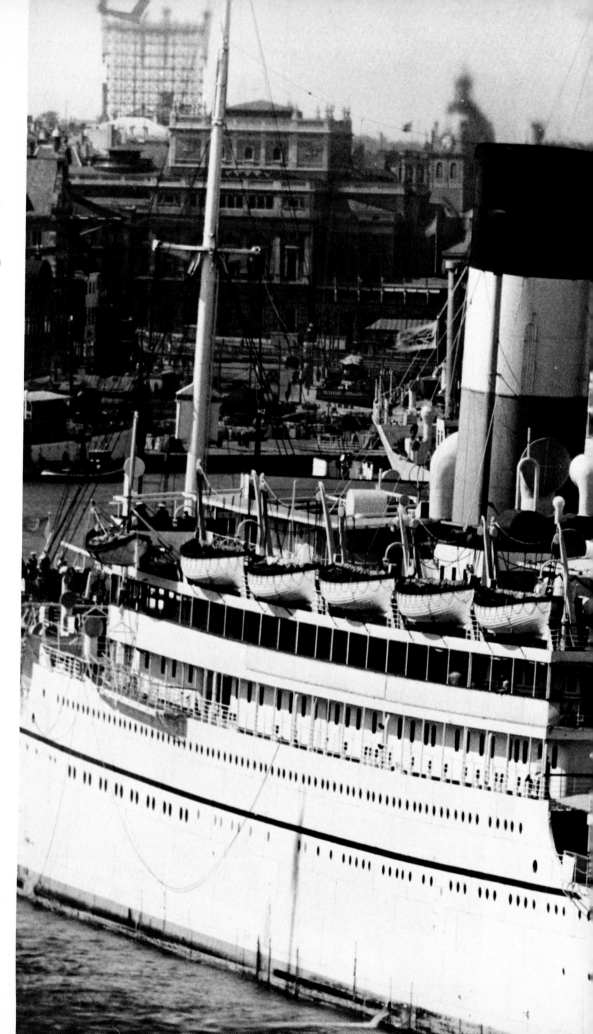

Tourist liners in
the harbor of
Stockholm,
photographed
with the camera
shown on p. 72
(c. 1935).

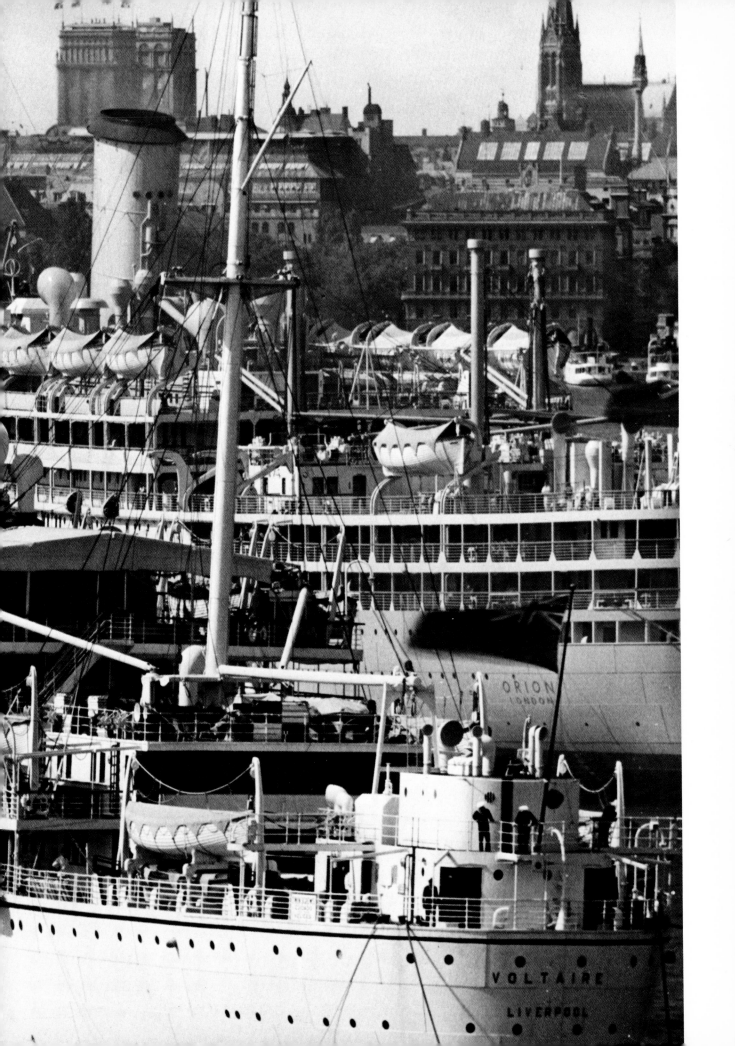

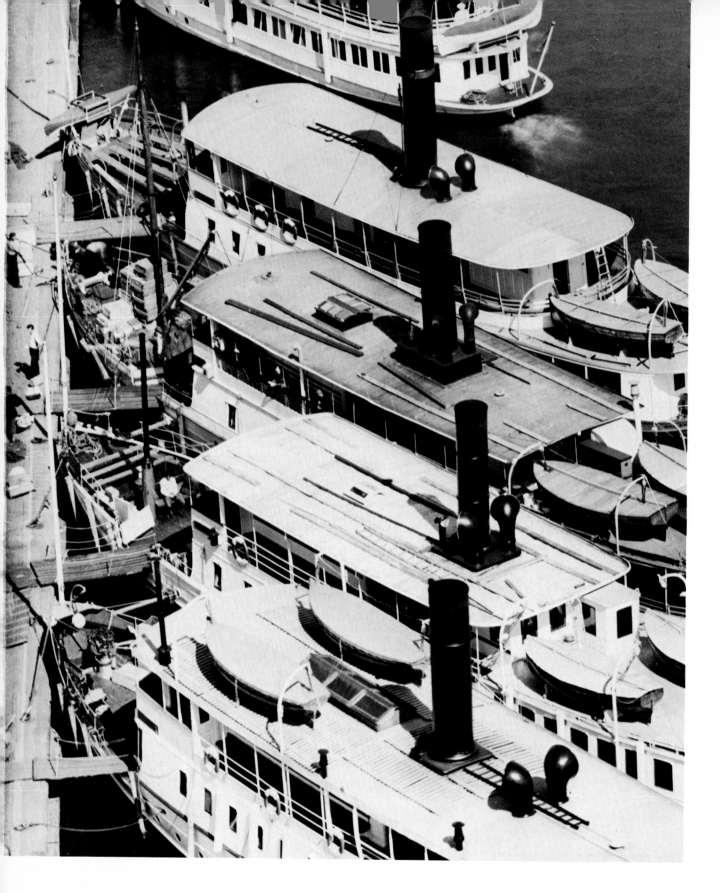

Above: lake steamers in Stockholm (1936). This is the original that gave rise to the bas-relief image on p. 61. On the opposite page is a view of Kornhamnstorg, Stockholm (1934). Due to the telephoto perspective, the schooner, the cars, and the buildings appear in virtually true proportion to one another.

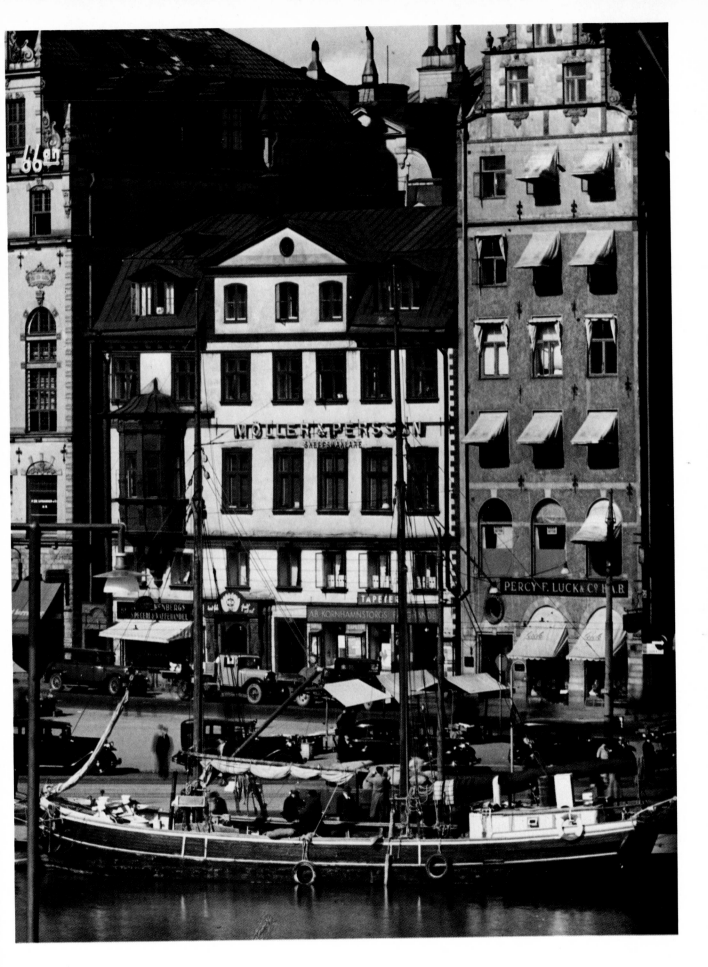

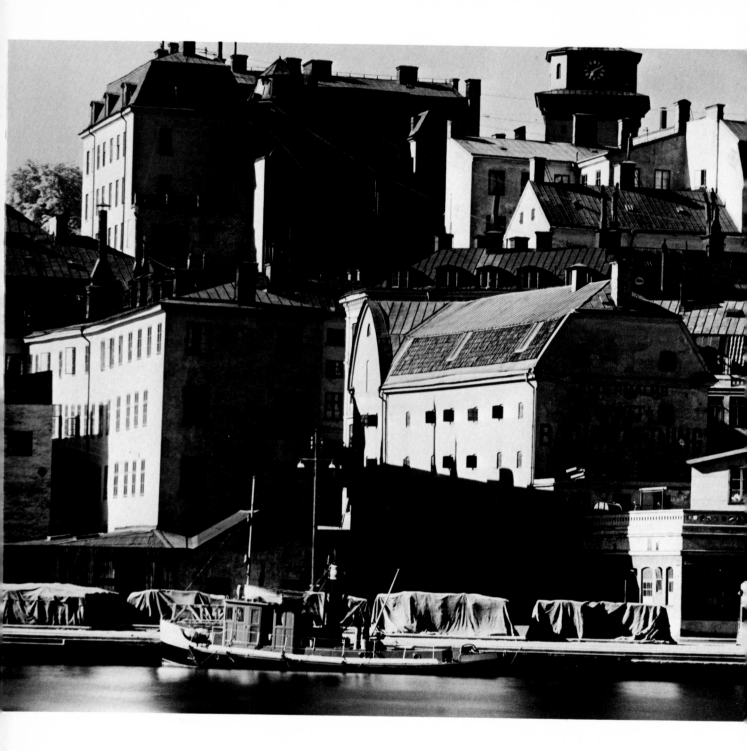

I wanted to show the ships and the buildings in their proper proportions to one another in this view of the Stockholm waterfront (Södermalm, 1934). The only way to accomplish this was by means of telephoto perspective. It was the nature of the subject—the great expanse of open water that is one of the glories of Stockholm across which I had to shoot to achieve

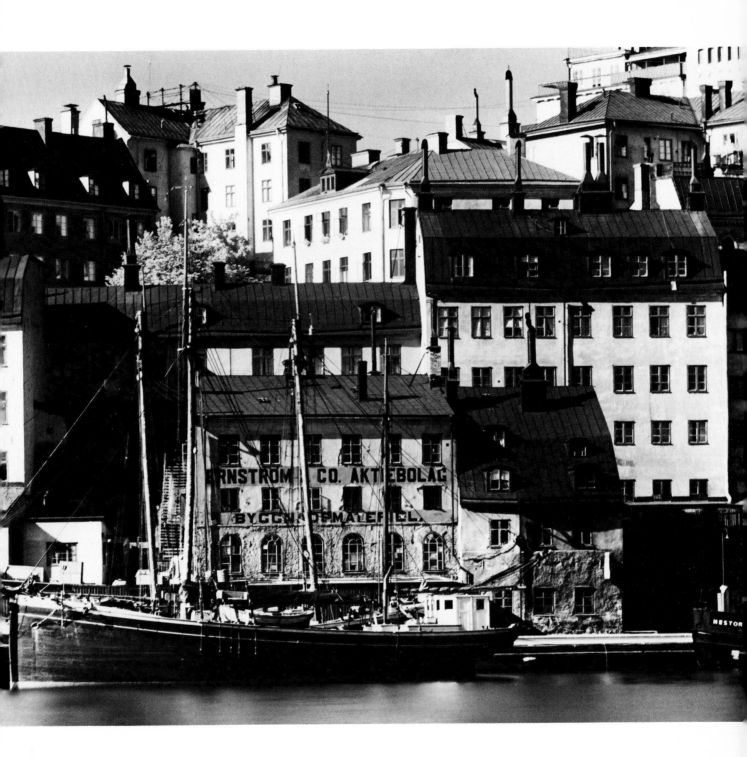

my aim—that forced me to construct the tool, my super-telephoto camera. Had I been living in any other place, I might not have gotten around to extreme telephotography until I came to New York, the superhuman aspects of which can likewise be captured effectively only by telephotography.

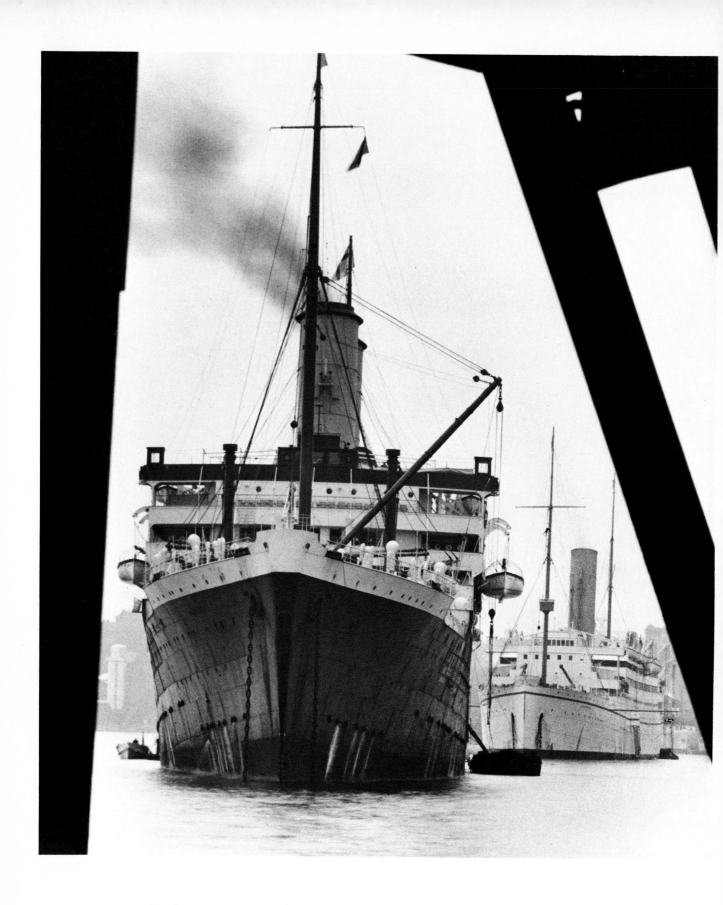

Tourist steamers outside Stockholm (1935). Only extreme tele-perspective can do justice to these magnificent ships and adequately capture the feeling of massive size. In my opinion, this form of rendition is more true to reality than the weaker impression derived by a person standing afar on the quay who sees these ships as toylike and diminished by distance.

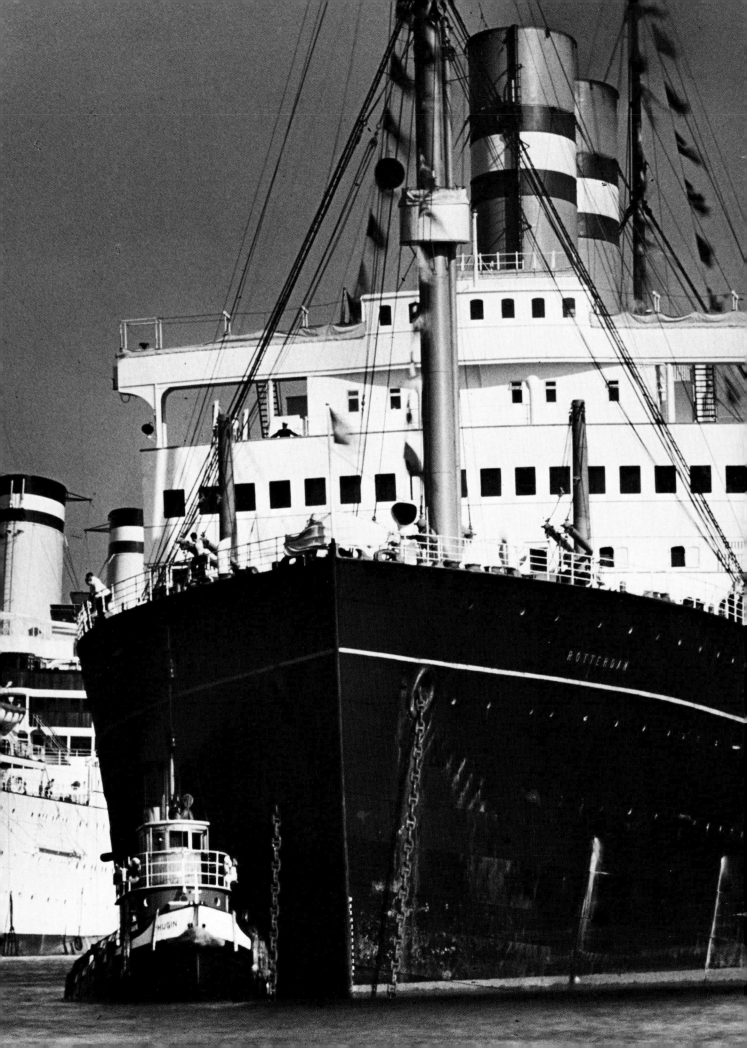

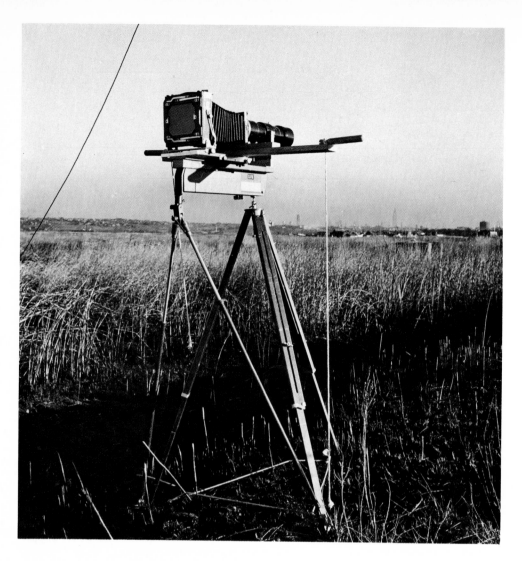

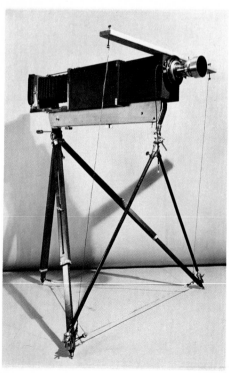

Shown here are two super-telephoto cameras equipped with lenses of 40-inch focal length and a "five-pod," which I constructed specifically to photograph the skyline of New York (1941). The five-pod, a girderlike structure of utmost rigidity (which can easily be folded for transport), supports the long telephoto camera in its entirety and prevents unsharpness due to otherwise unavoidable vibration. It was my own invention born of necessity—no adequate commercial product was available at that time (nor is one available today). The crosspiece atop the front of the camera is a wind brace that further stiffens the structure. The ghostly image of the Empire State Building can be seen in the distance—precisely as it appeared to the eye—rising above the horizon to the right of the camera.

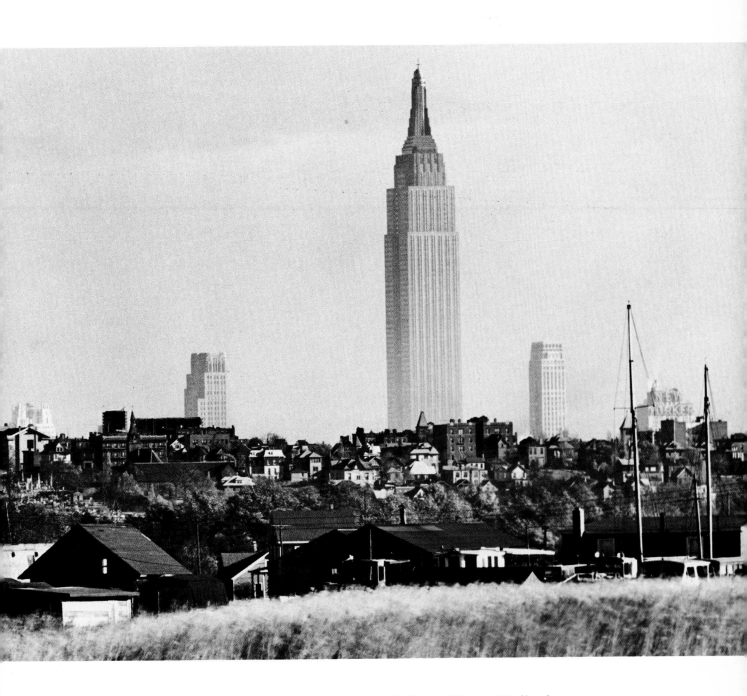

The Empire State Building, New York, photographed across the Hudson River and the New Jersey marshes from the location and with the setup shown in the picture at the top of the opposite page (1941). Although this image seems very different from the impression received by the eye at the time the photograph was made, calling it "unnatural" would be wrong because it expressively reflects *the feeling* of the scene: There, far away on the horizon, looms a structure built by giants, an immense construction the full size of which can only be felt rather than seen because it is too far away.

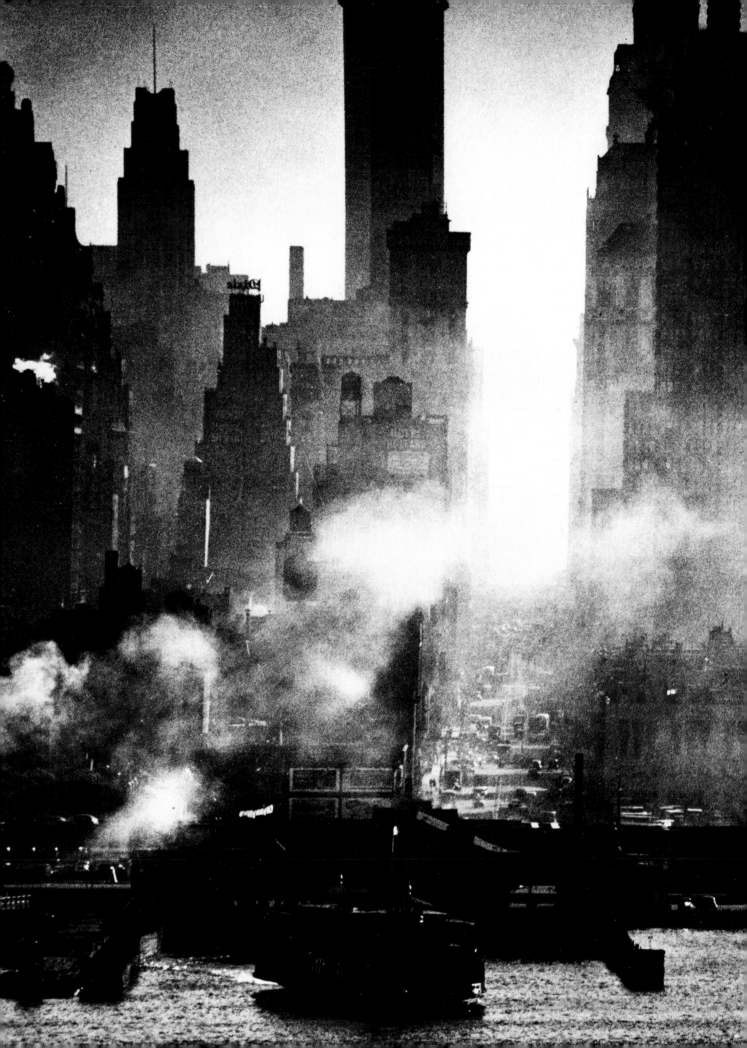

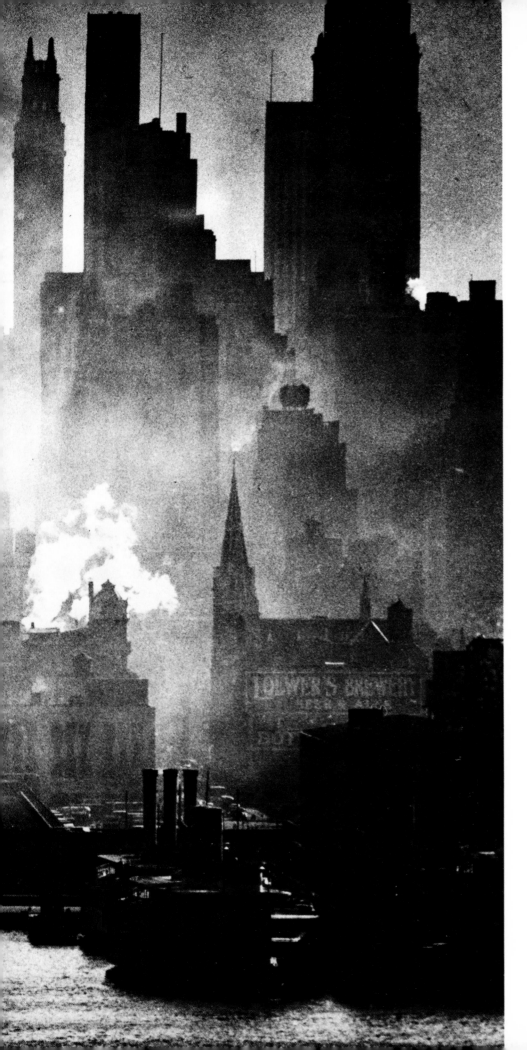

Midtown Manhattan photographed across the Hudson from Weehawken, New Jersey, with a 40-inch telephoto lens (1942). Camera position is exactly opposite of Forty-second Street. Only a super-telephoto camera could have created this powerful image.

Traffic on Fifth Avenue (1948) is shown on page 86.

Page 87 shows lunch hour on Fifth Avenue (1949). To the best of my knowledge, these were the first times that a super-telephoto lens with a focal length of 40 inches was ever used for "close-up photography" on the street.

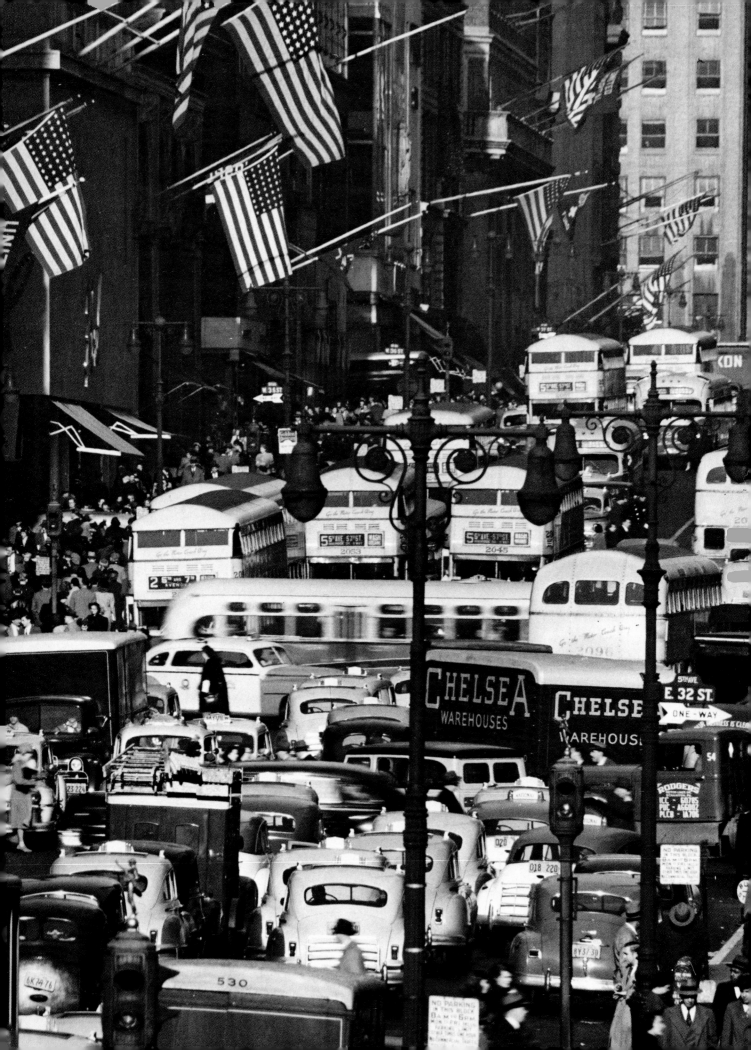

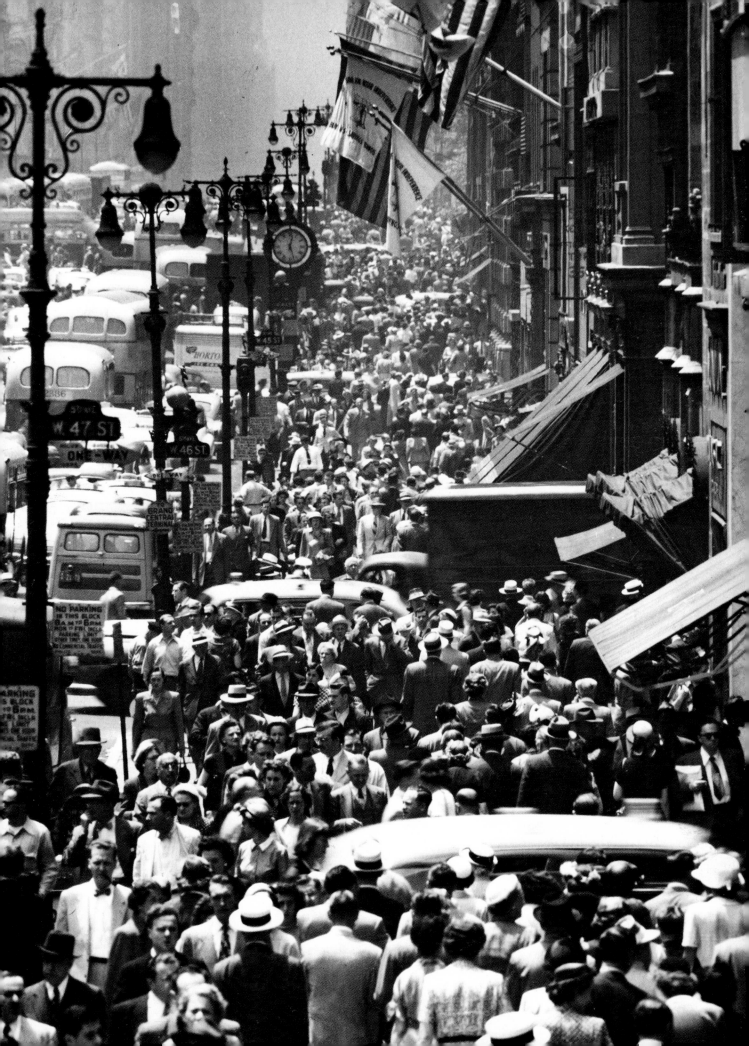

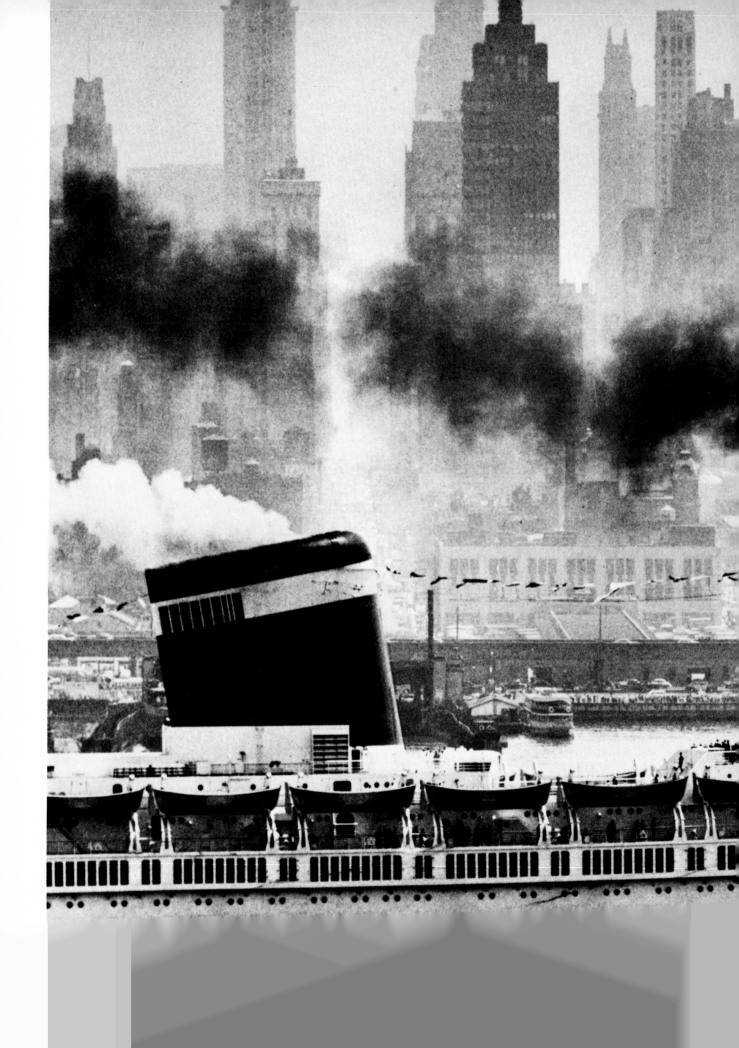

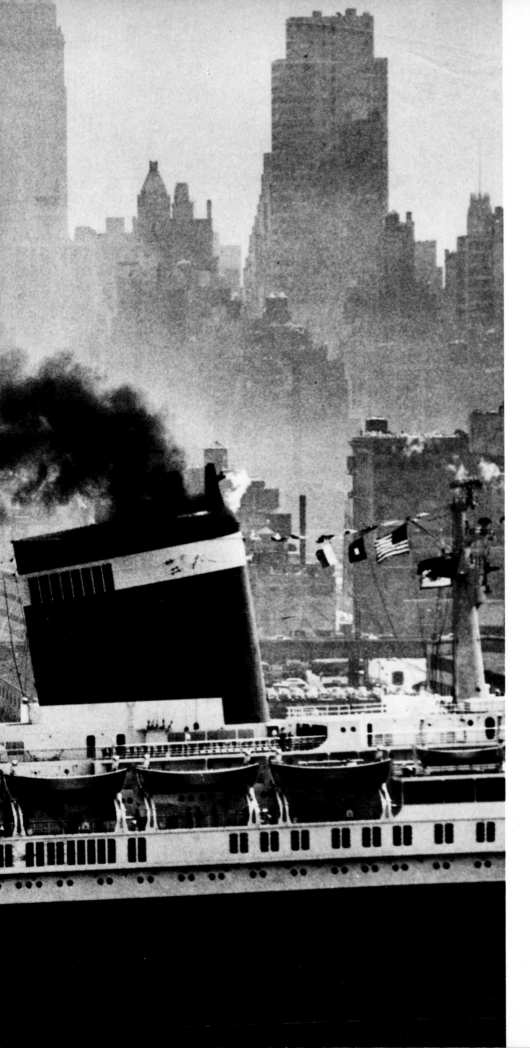

I made this shot of the liner *United States* passing Forty-second Street on her way out to sea (c. 1963) with a 3¼″ × 4¼″ camera equipped with a lens having a focal length of 24 inches. Again, only extreme telephotography could have given me the kind of image I had already seen in my mind.

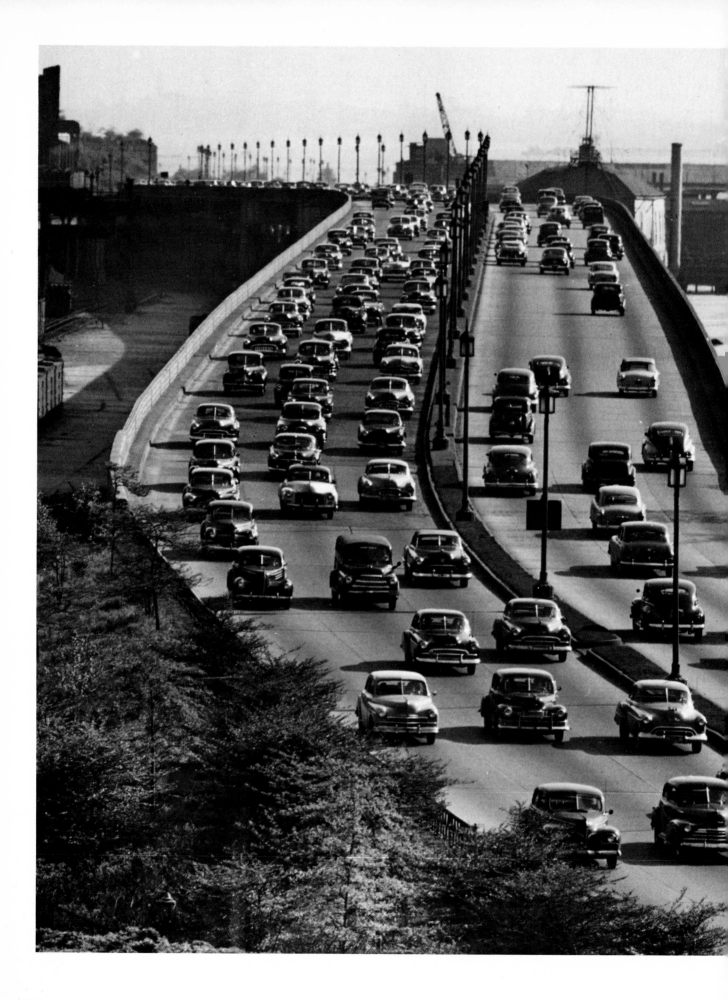

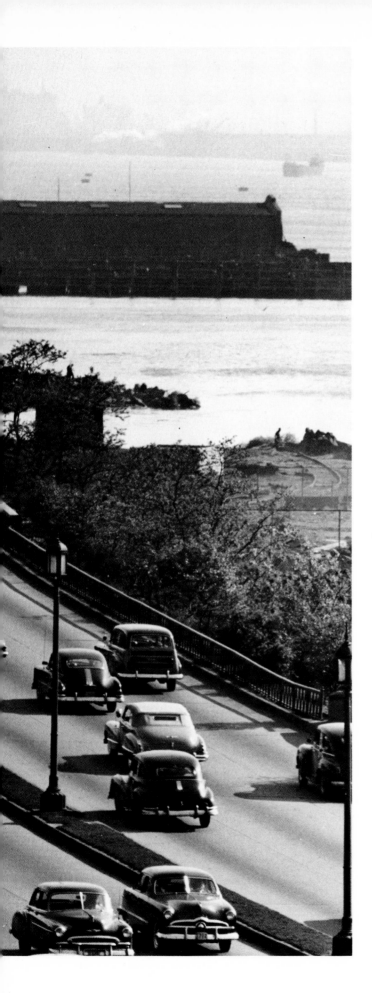

The West Side Highway, New York (1950). Only the "space-compressing" effect of tele-perspective can adequately re-create the feeling of bumper-to-bumper traffic.

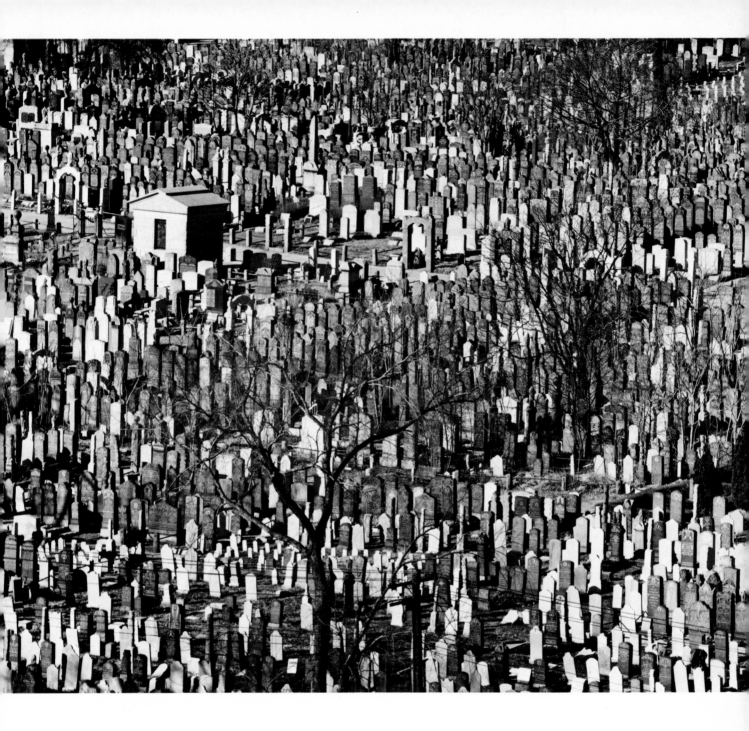

Left: the Pan Am Building on Park Avenue, seen from around Sixtieth Street (c. 1965). Above: Jewish cemetery in Queens (1952). These two impressions of New York required an extreme telephoto lens to express what I felt when I found myself face-to-face with these scenes—the crowding due to lack and cost of space, the regimentation, the reduction of all human values to considerations of dollars and cents, corporate profits and cost control, disregard if not contempt for all natural aspects, the environment consisting almost exclusively of concrete, glass, and stone, the cold impersonality of a giant city. . . .

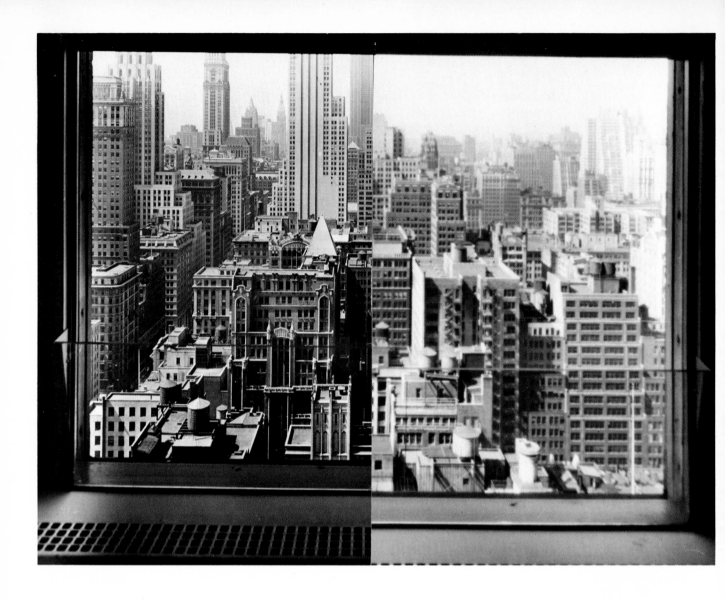

Superhuman perspectives. Having "discovered" the power of the telephoto lens, I became obsessed with the creative potential of different types of lenses. The experimental images shown on this spread were made in 1945. The left half of the view above was made with a standard lens for purposes of comparison; the right half with a "pinhole lens." Its peculiar, "gentle" softness hints at creative possibilities.

Both images on the opposite page were made with an ordinary magnifying glass, the top one at full opening, the lower one "stopped down" with the aid of an auxiliary cardboard aperture. What interested me was the degree of distortion—both with respect to sharpness and linearity —which actually corresponds more closely to human vision (allowing us to see sharply only the center part of a view) and to reality since, as I showed on pp. 32–33, straight lines are bound to curve as a result of perspective. However, I never got around to creatively exploiting this particular aspect of perspective.

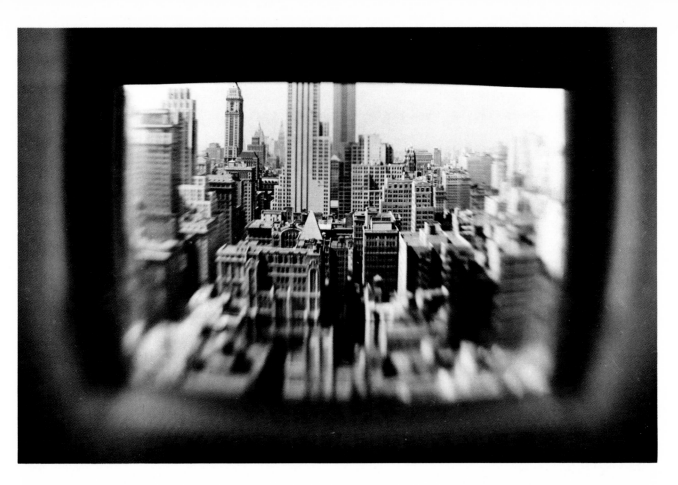

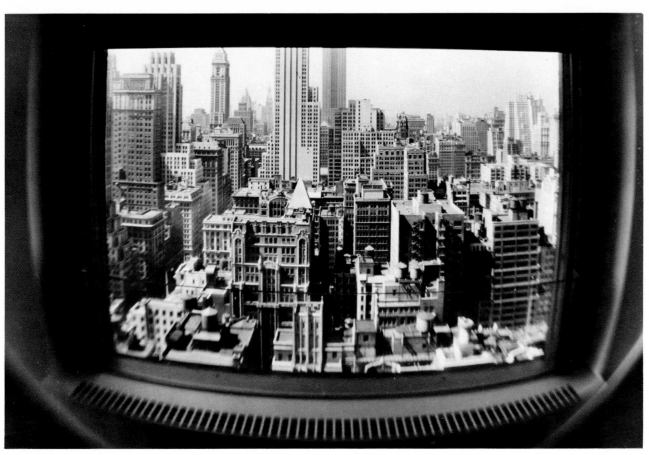

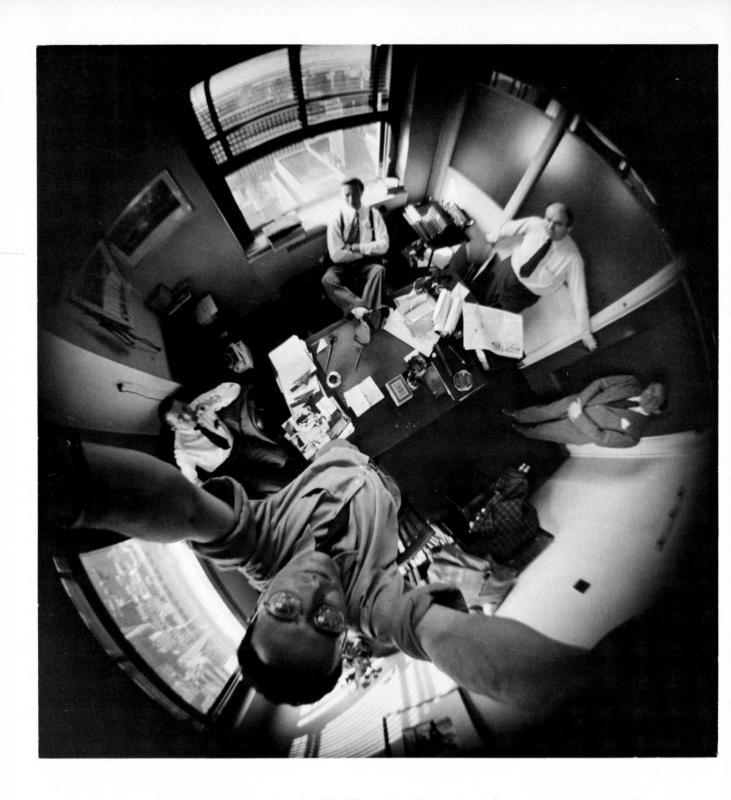

Above: a 180-degree view of a *Life* office made with a captured German fish-eye lens (1949). I am holding the small camera above my head pointing straight down, and what appears to be widely spread arms is only the result of extreme "distortion," since my hands are less than six inches apart. The potential of this kind of imagery is staggering. Opposite page: deliberate distortion of a portrait with the aid of an enlarger (1929). The technique used was the same as that described on p. 28.

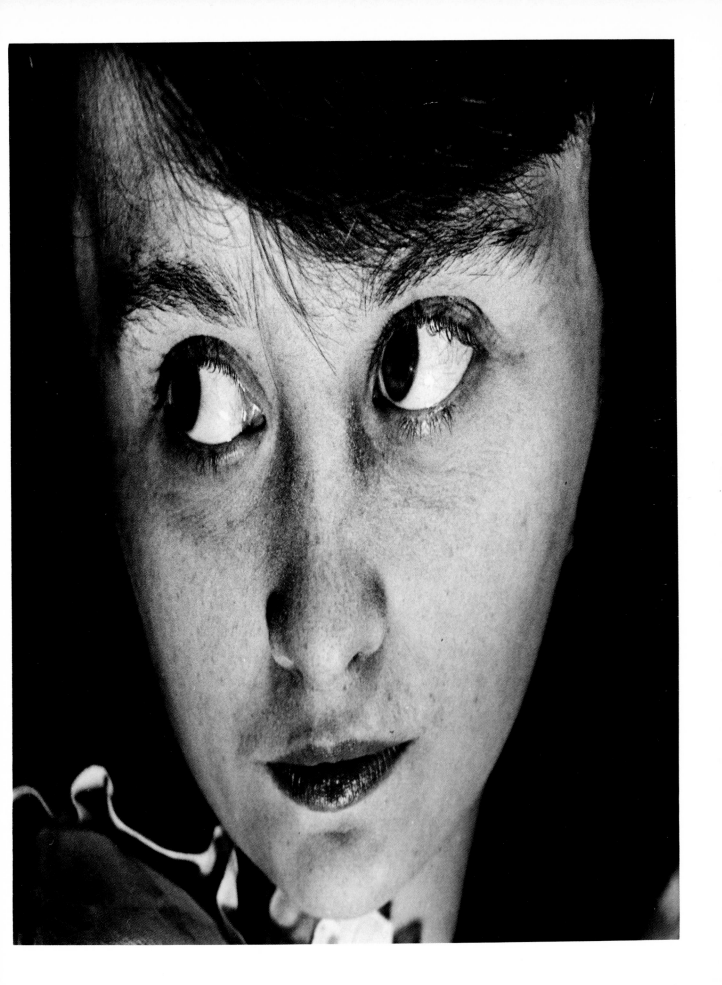

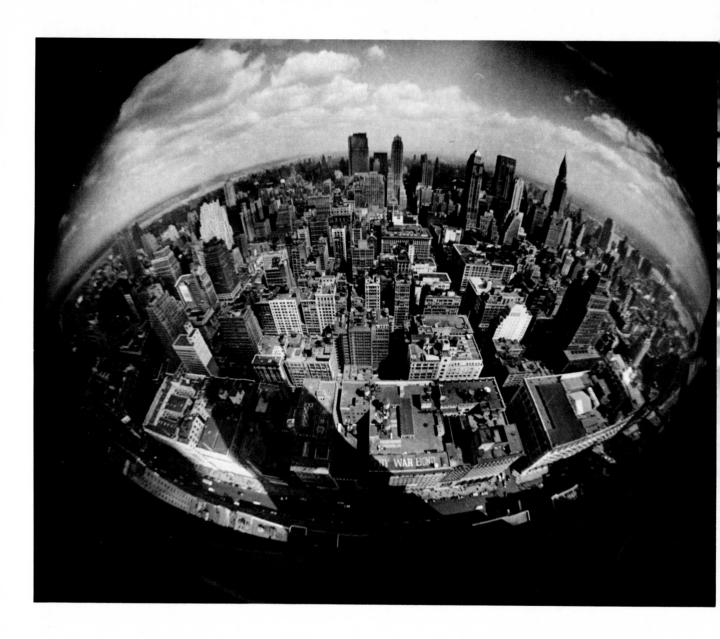

Above: a view of Manhattan taken from the Empire State Building with a captured German fish-eye lens (1949). Opposite page: modern office buildings reflected in one of the mirrored spheres that form part of a fountain in the sunken plaza in front of the McGraw-Hill Building on Sixth Avenue, New York (1976).

In both cases, perspective is "unnatural"; however, this strangeness is not accidental, but deliberate—the result of contemplation and choice. The image above transforms New York into a megalopolis covering the major part of a minor planet—a symbolic expression of its position as the financial and cultural center of the world. And the view on the opposite page tries to capture some of the feeling of overpowering massiveness, of gigantic structures closing in, threatening to crush the insignificant human ant that created them—monstrous, dangerous, ruthlessly pursuing profits at the expense of human dignity and life.

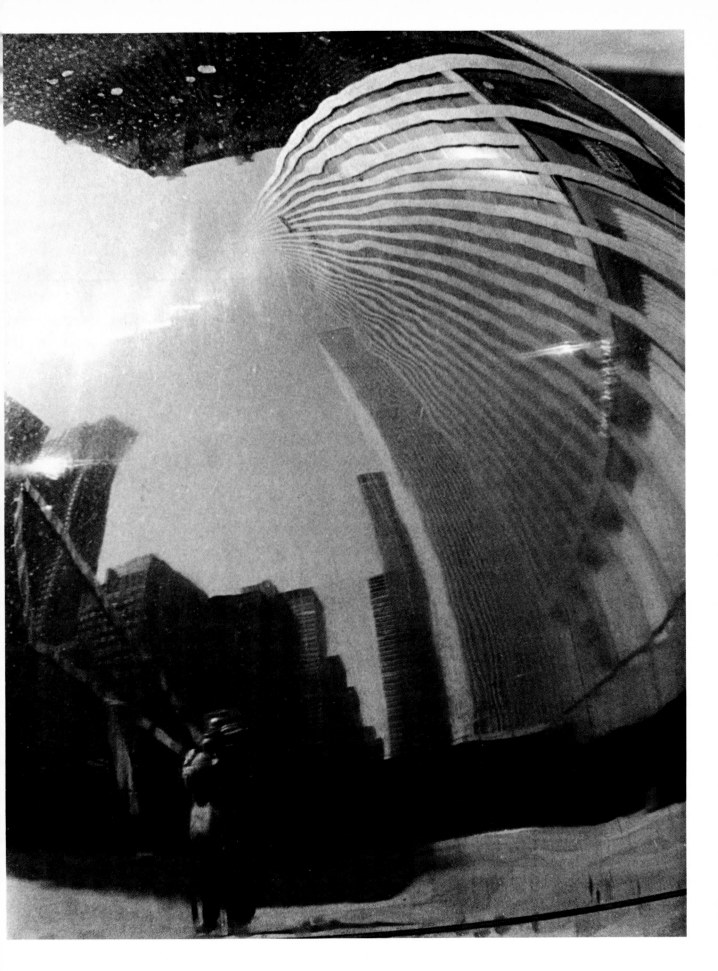

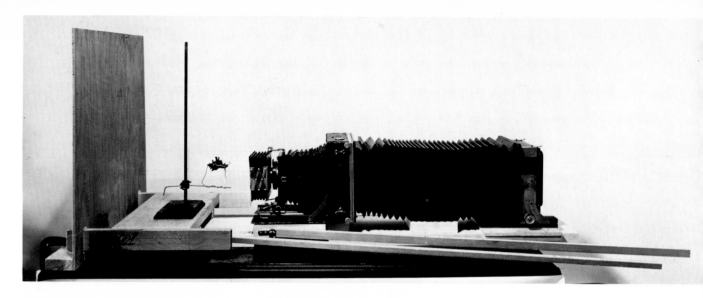

Extreme close-up photography. Ever since I realized that the camera could be used as a tool to widen my visual experience, I made it a point to make the most of this potential. I began by exploring the realm of the photographic control processes (pp. 42–71); then I got involved with telephotography (pp. 72–93); and lastly, stimulated by two *Life* assignments (*Insect Engineers,* August 29, 1949, and *Pest Portraits,* March 20, 1950), I devoted more and more time to a photographic exploration of the world of the near and small.

Since I was interested only in three-dimensional subjects and wanted full control over the illumination, low-power photomicrography was out. And since the kind of equipment I needed was not commercially available, I had to build it myself. The picture at the top shows my second super close-up camera, a 5″ × 7″ Linhof Technika with a 55-inch bellows capacity and interchangeable backs, accepting either 4″ × 5″ sheet film holders or 120 roll-film magazines. The front, of course, could be equipped with any kind of lens.

The picture at the left (by Lois Hobart) shows the author working with a home-modified Hasselblad. The modification consisted of an 18-inch bellows permitting both front and rear focusing in conjunction with a sliding socket plate that enabled me, after setting the focus for any predetermined scale of rendition, to slide the prefocused camera back and forth until the ground-glass image was sharp. The picture on the opposite page shows the head of a live male Luna moth made with this setup (1955).

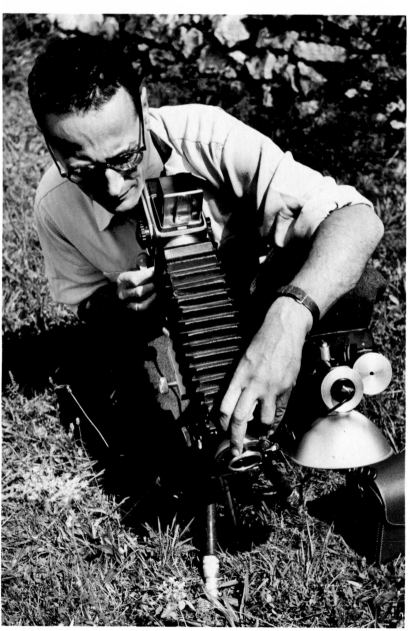

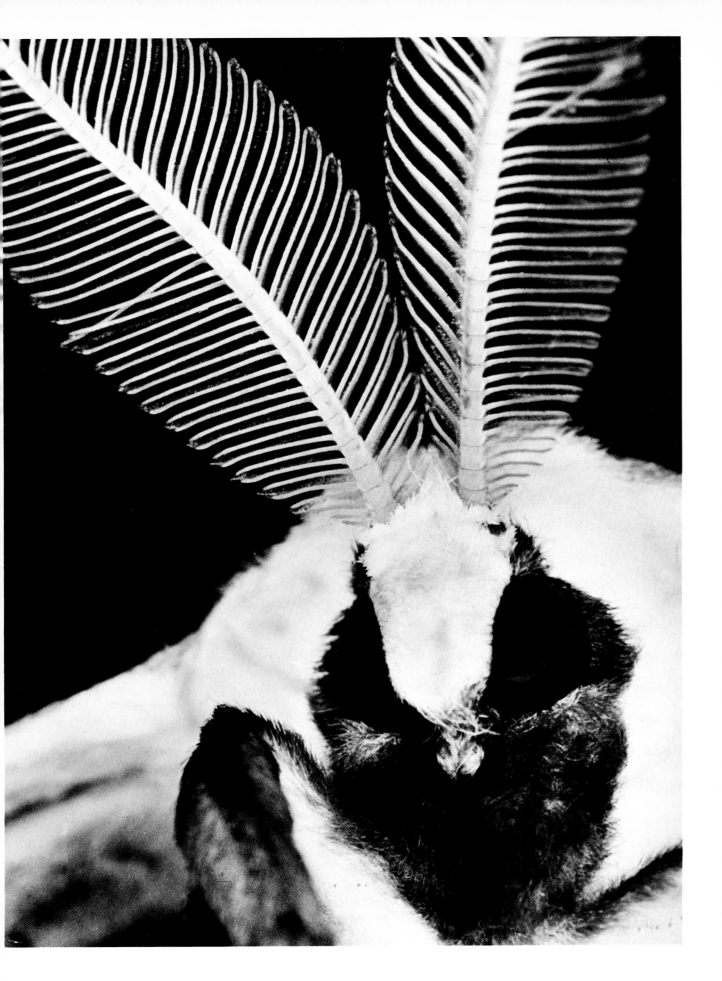

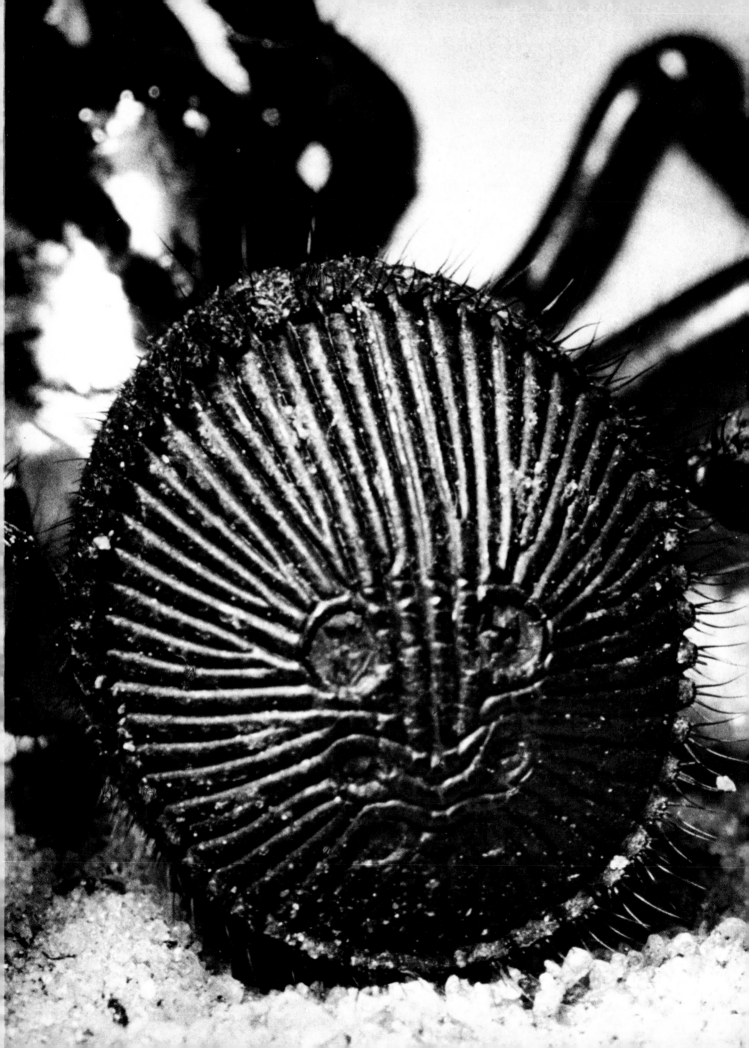

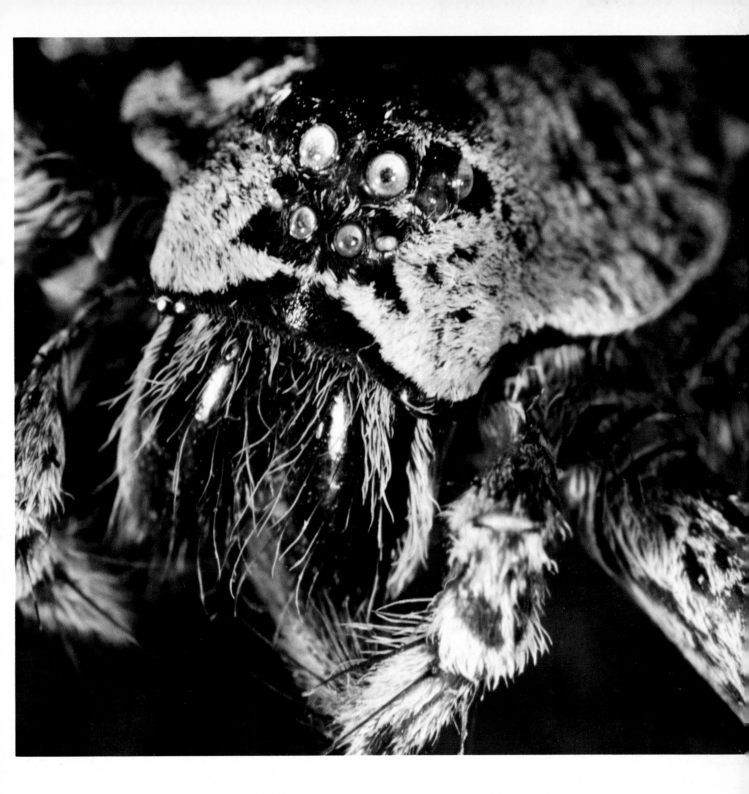

Above: head of a wolf spider (1949). Opposite page: rear view of a trapdoor spider (1951). The amount of detail brought out by the camera that is invisible to the unaided eye is astonishing and, to me, a never-ending source of wonder and enjoyment.

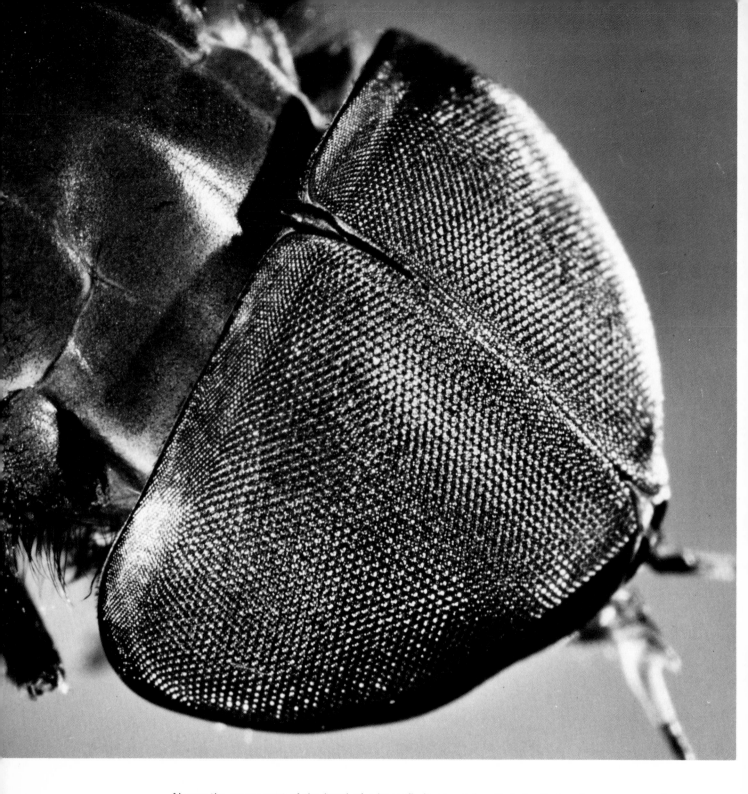

Above: the upper part of the head of a horsefly is covered entirely by its two huge compound eyes (1949). On the opposite page is a yellow garden spider in its web (1951). I found that the best time to photograph spider webs is shortly after sunrise on a foggy morning before the sun is high enough to burn the dewdrops off the strands; once they are dry, the strands become invisible.

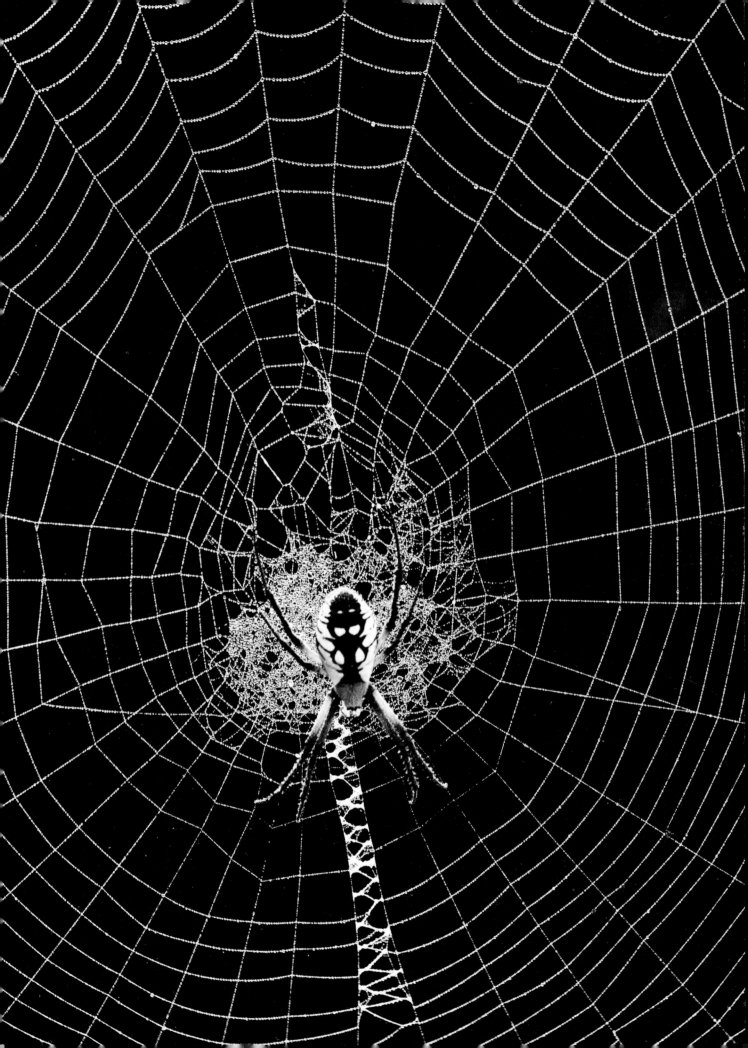

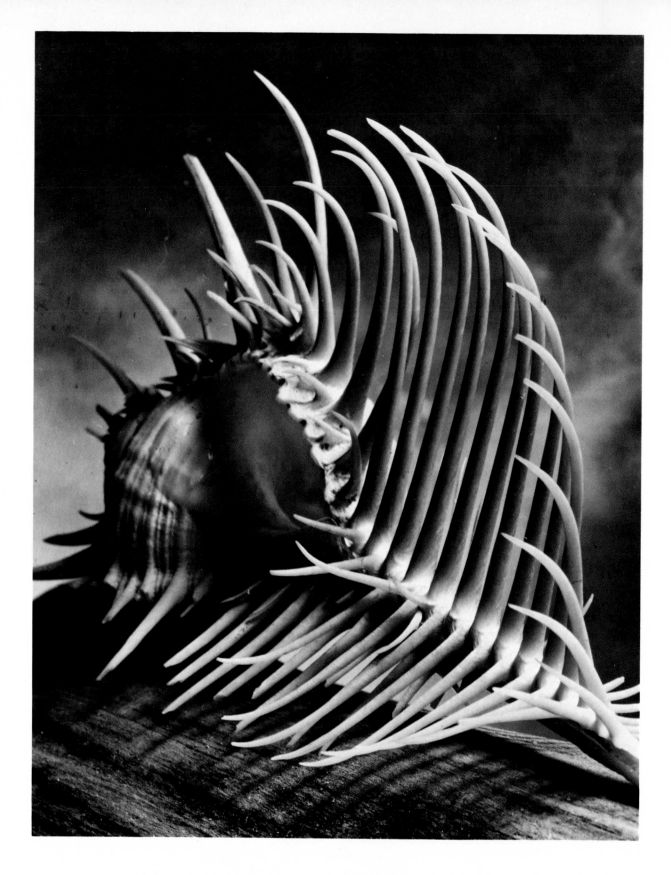

Above: *Murex triremis* Perry. Opposite page: *Terebra triseriata* Gray. In 1970, in preparation for a picture book on shells (*Shells,* The Viking Press, New York), I began to experiment with new and more significant ways of presentation than the traditional ones. I explored the possibilities of natural instead of artificial backgrounds in conjunction with a new, low, horizontal angle of view instead of the usual one from above.

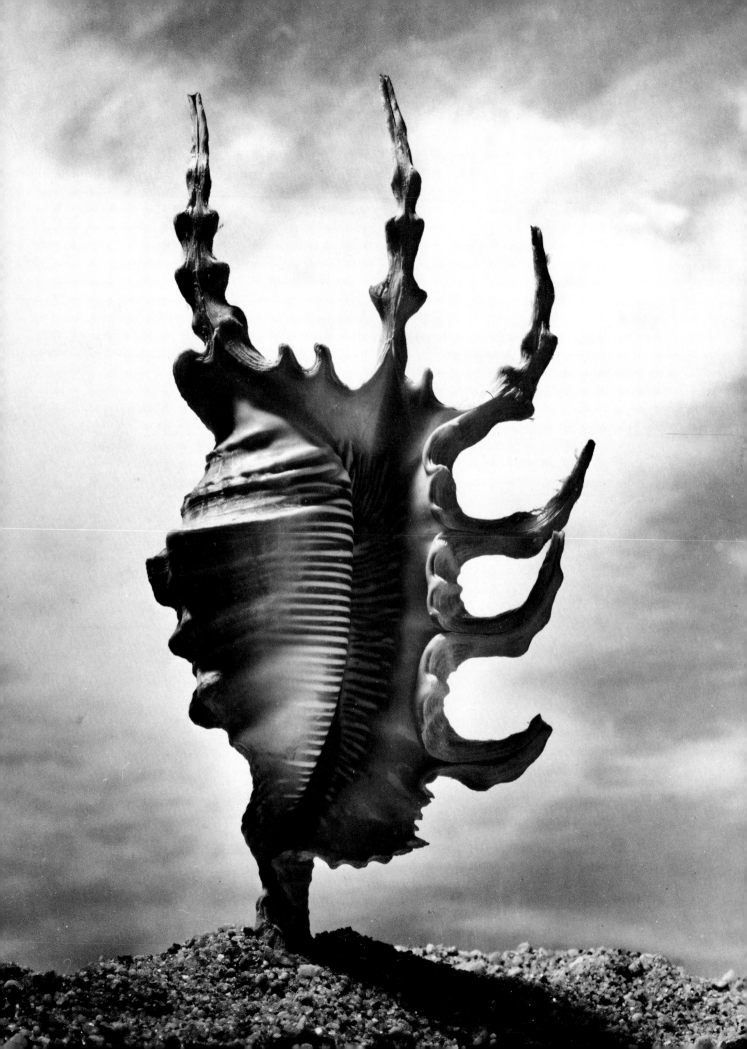

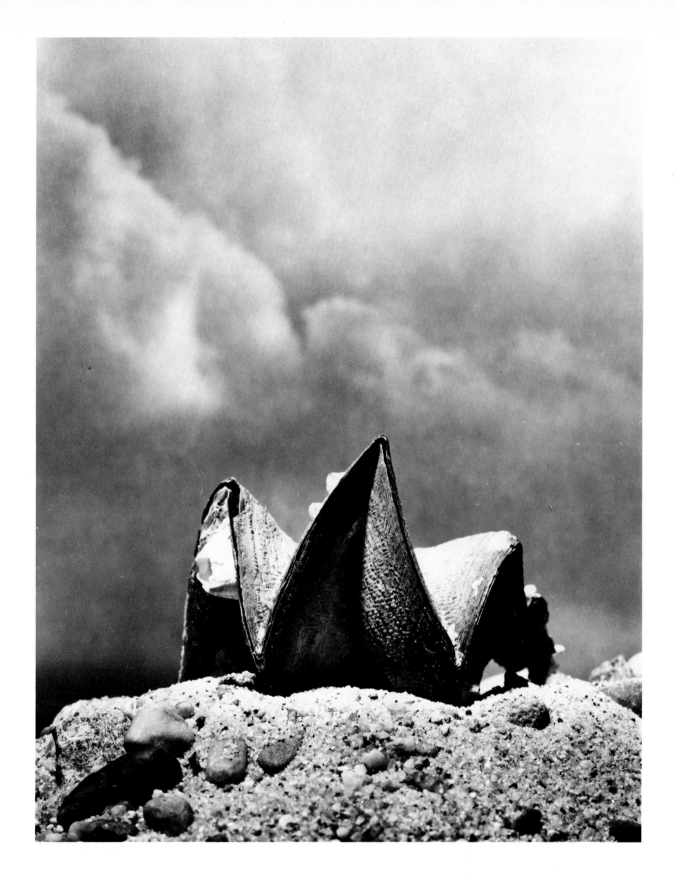

Above: *Lopha cristagalli* L. Opposite page: *Lambis scorpius* L. Why not pose a shell standing upright in the sand? Or show it as if it were a tiny A-frame beach house? Unnatural? Perhaps, but why not? After all, the only "natural" way of showing a shell would be in its natural habitat —underwater. To me, these fantastic shapes seemed to require a fantastic form of presentation in order to become fully effective in picture form.

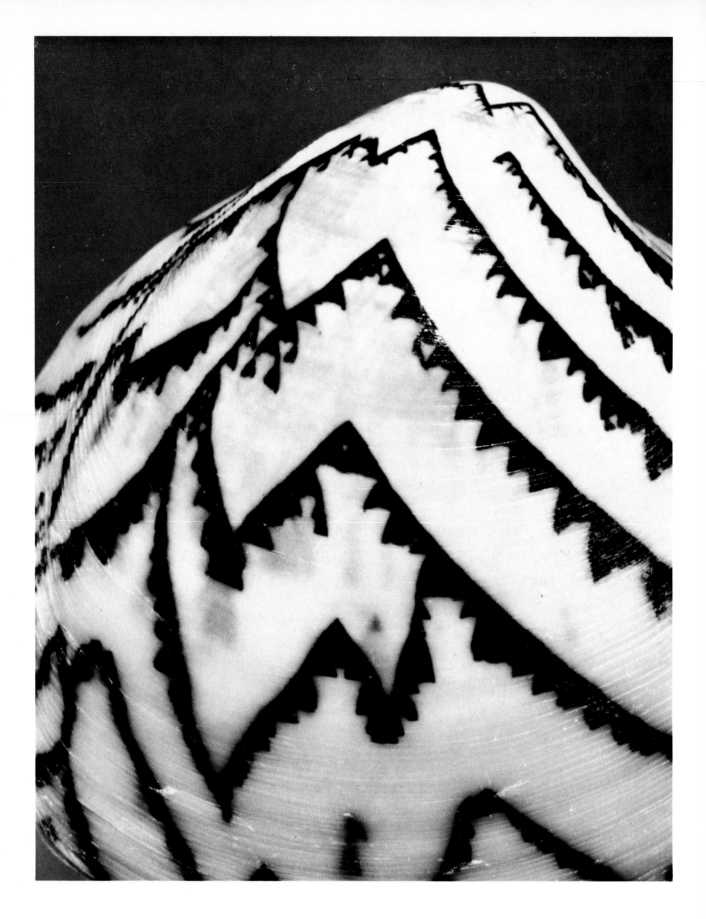

Above: *Lioconcha castrensis* L. Only an extreme close-up can do justice to the exquisite beauty of this 2-inch shell (1970).

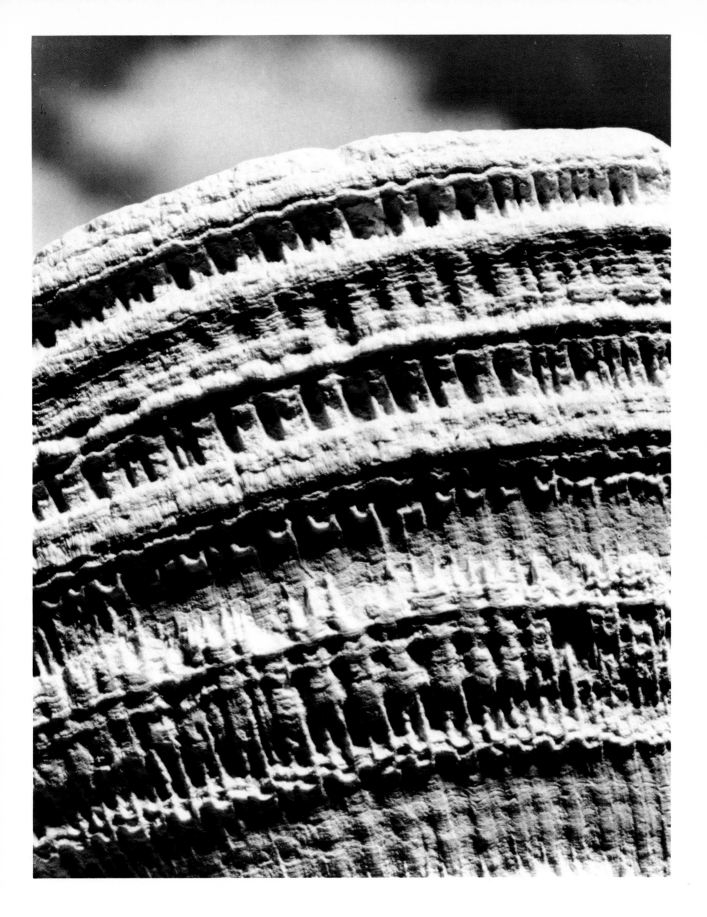

Detail of an eroded quahog shell shown here 12 times its natural
size. To me, its beauty rivals that of a classic frieze (1976).

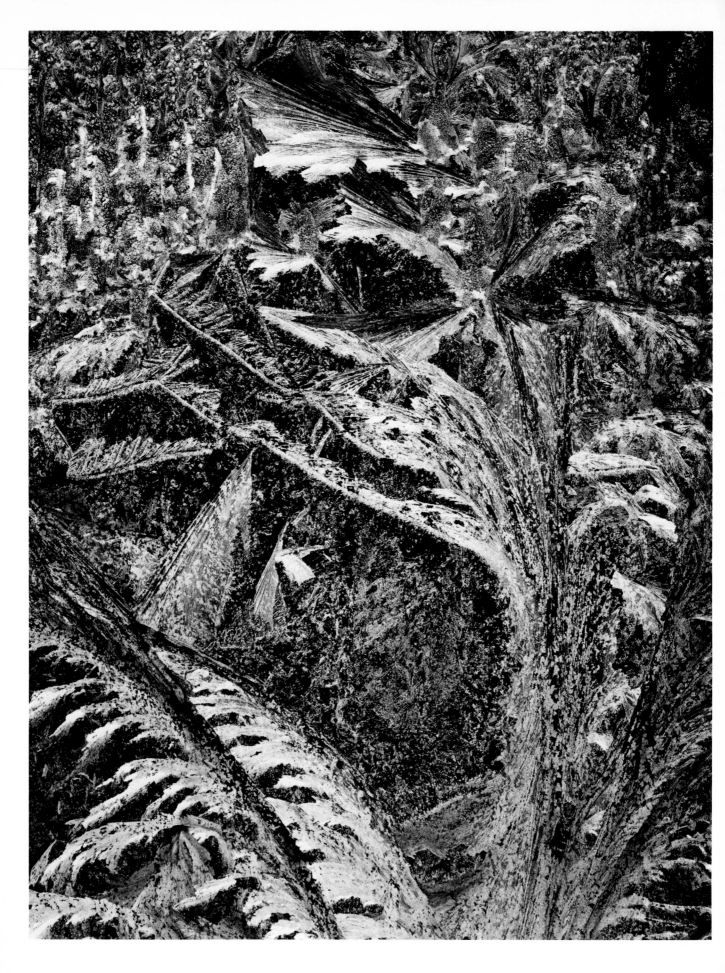

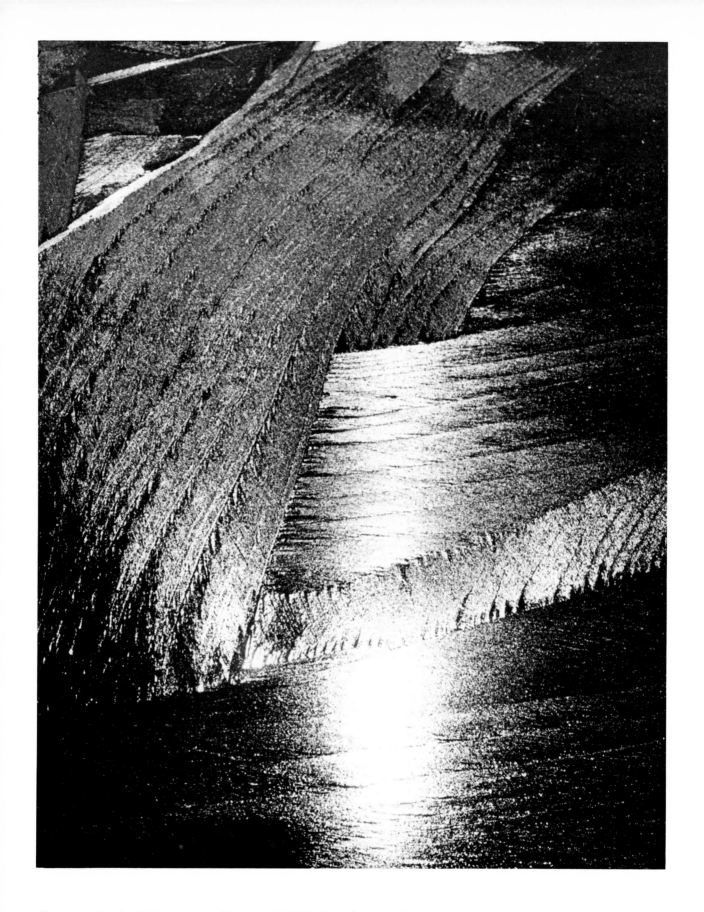

Above: pond water in the process of freezing (1952). Opposite page: frost pattern on a window pane (1946). Structures of exquisite beauty, too small to be seen by the unaided eye, are revealed in their full glory through extreme close-up photography.

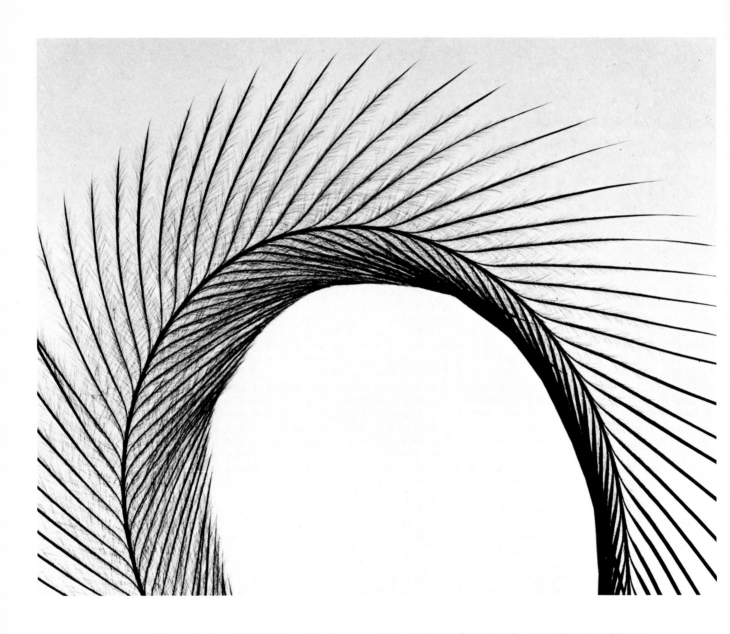

Above: feather (1965). Opposite page: concretion (1973). Occasionally, to achieve the ultimate in graphic clarity and precision of rendition, I require a pure white, shadowless background for my subjects. A light box, of course, seemed the natural answer to my problem. Commercially available light boxes, however (as I soon found out), besides being quite expensive, are inadequate for my purpose because their light distribution is uneven and their surface too shiny to avoid reflections. Once more I found myself forced to experiment, this time with combinations of different kinds of light sources and surface materials until I found the one that provided me with the perfectly uniform, reflection-free and glare-free background I needed. The photographs on this and the following spread testify to its efficiency; it completely eliminates the costly process of silhouetting with an airbrush.

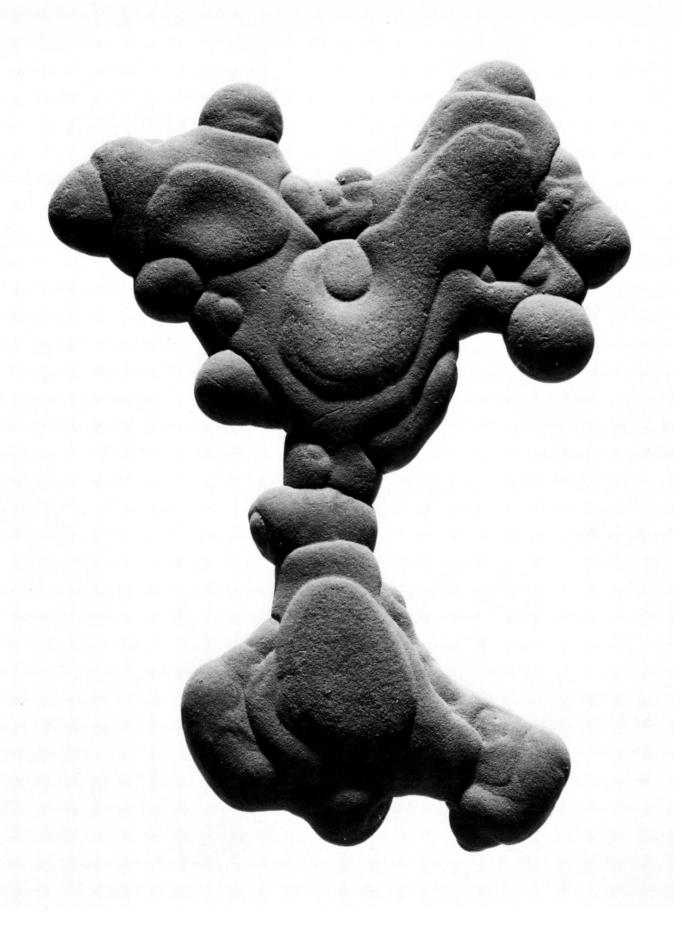

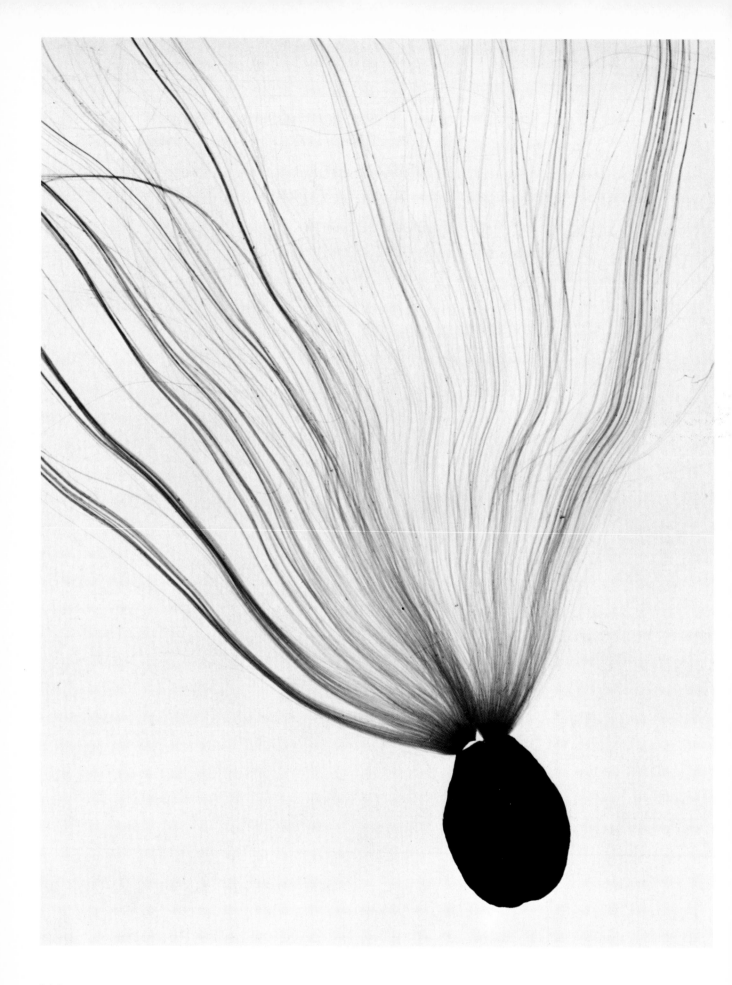

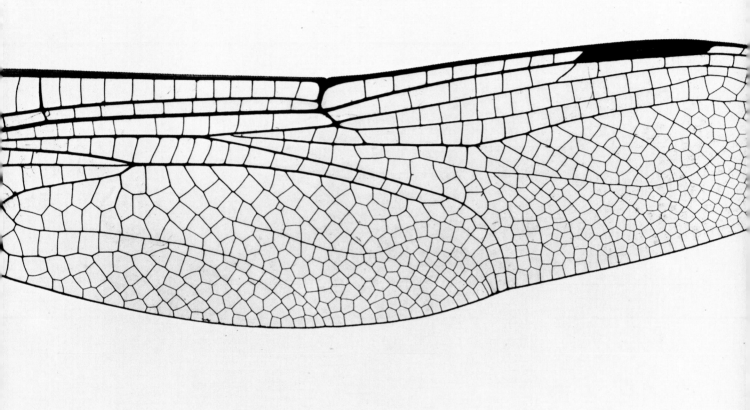

Above: wing of a dragonfly (c. 1950). Opposite page: milkweed
seed (c. 1950). Delicate structures like these can be shown to their
best advantage only against a pure white background.

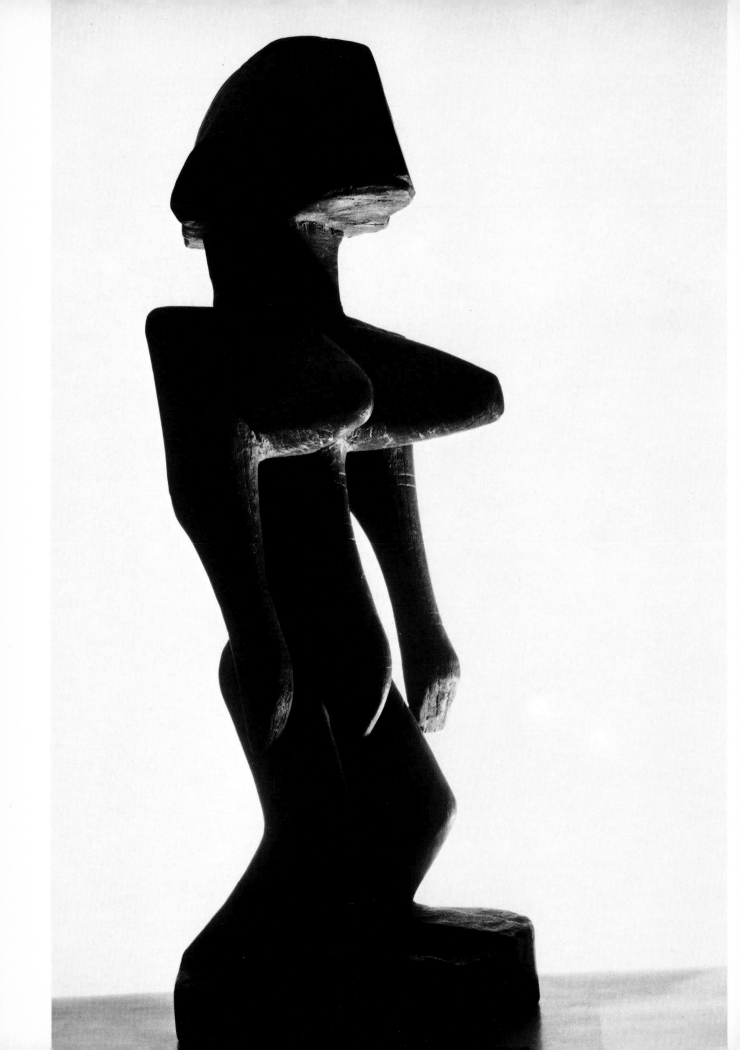

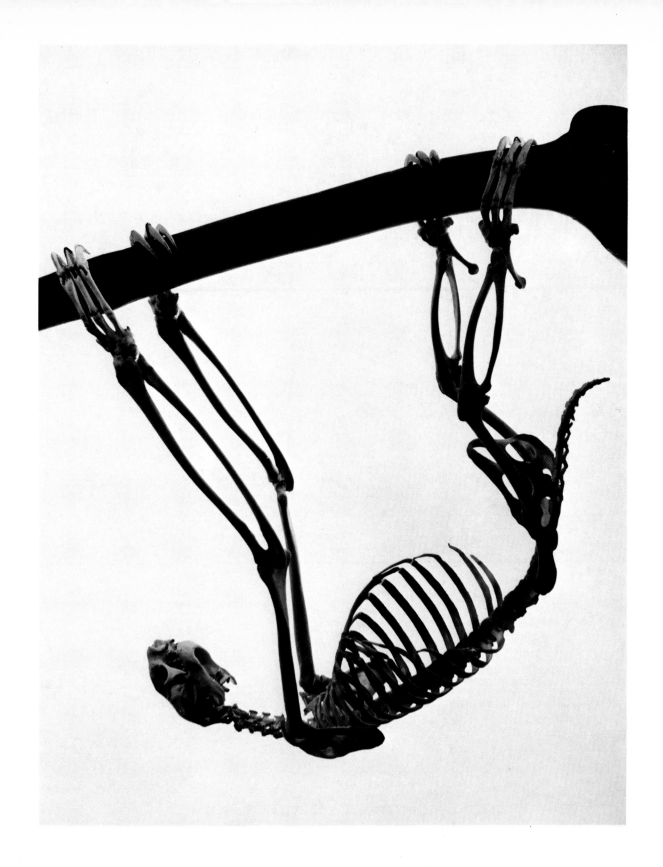

Above: skeleton of a sloth (1951). Opposite page: African fetish, Bambara tribe, Sudan (c. 1956). Whereas the ideal of conventional photography is to achieve the maximum of subtly differentiated shades of gray, creative photographers know that the most graphically powerful effects are produced by means of pure black and white. On this and the following spread are some of the images that are based upon experiments that I performed to achieve control over this form of photographic expression.

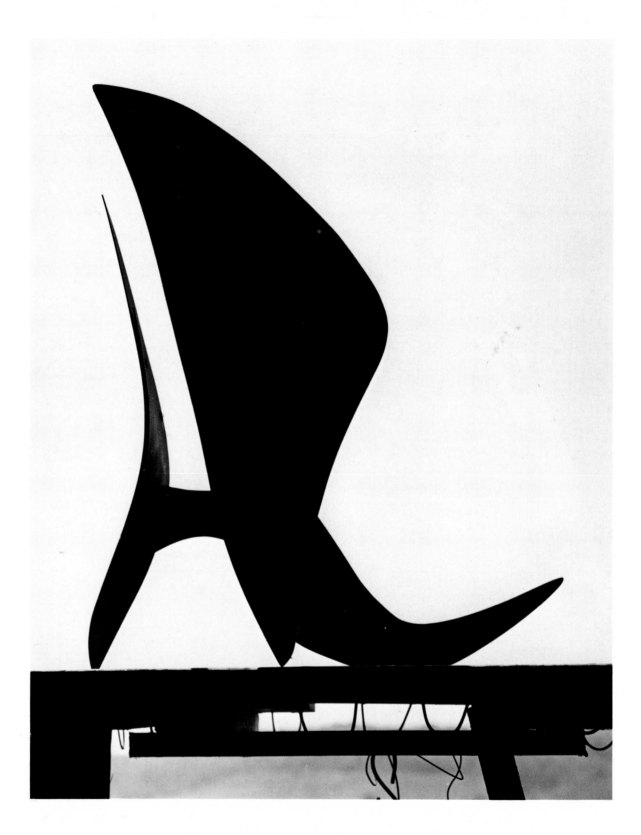

Above: a "stabile" by Alexander Calder (c. 1964). Opposite page: "The Doctor" (1955). Simplification, stylization, and abstraction achieved through contrast between black and white create photographic images that, by reducing the subject to essentials, evoke more powerful reactions than the actual experience itself.

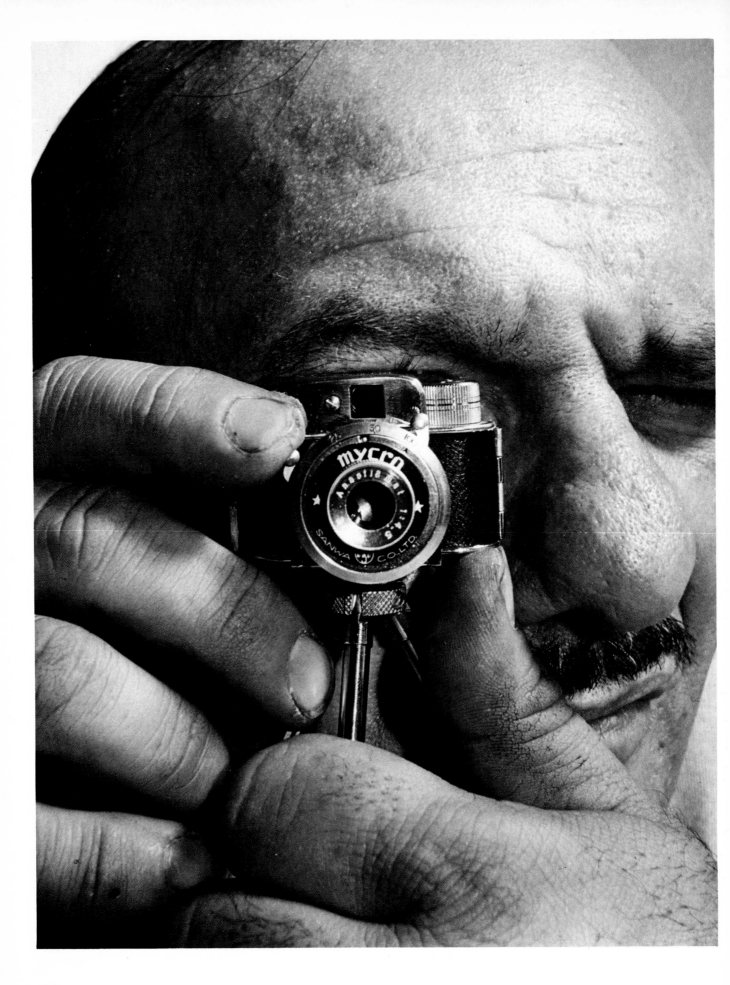

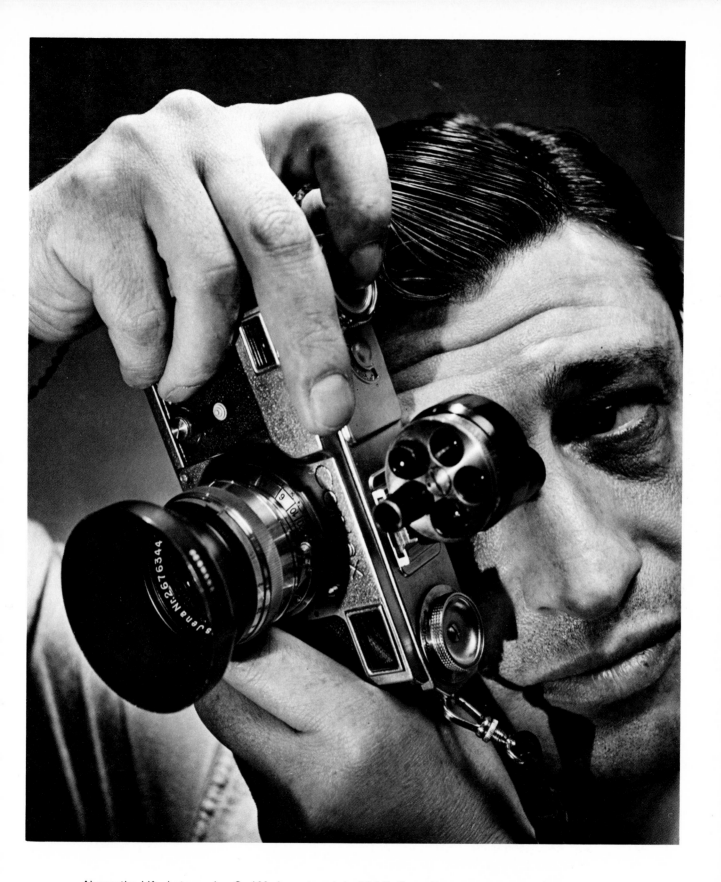

Above: the *Life* photographer Carl Mydans at work (c. 1946). Opposite page: an amateur photographer with a Japanese subminiature camera (c. 1949). What is experimental about these pictures? The deliberate use of tight cropping (which today, of course, is commonplace) in conjunction with "perspective distortion" to symbolize extreme closeness—a form of intensified seeing made possible only via the camera.

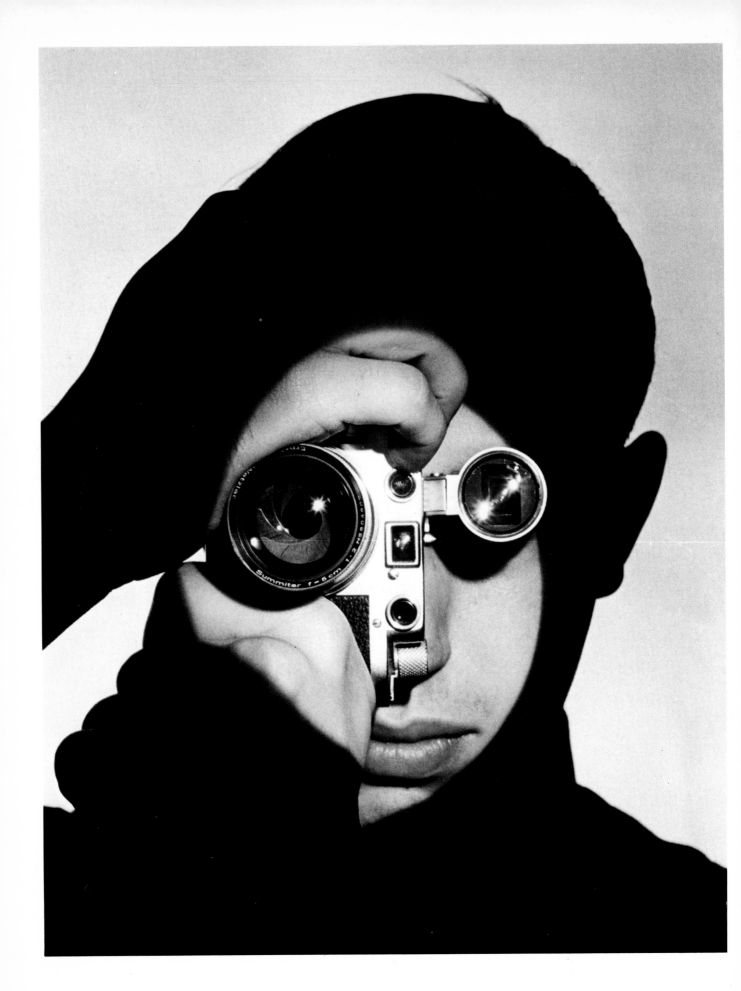

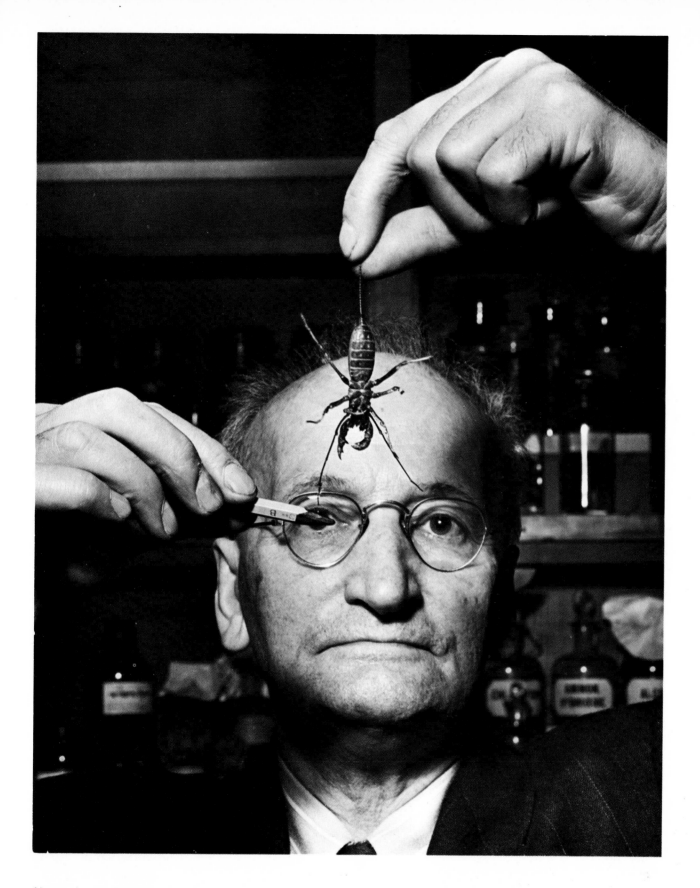

Above: the arachnologist Professor Alexander Petrunkevitch of Yale University holding a whip scorpion (c. 1947). Opposite page: "The Photojournalist" (Dennis Stock) (1951). Two unconventional, "experimental" portraits conceived to tell something about the profession, interest, or specialty of the depicted person, thereby giving the viewer a more significant picture.

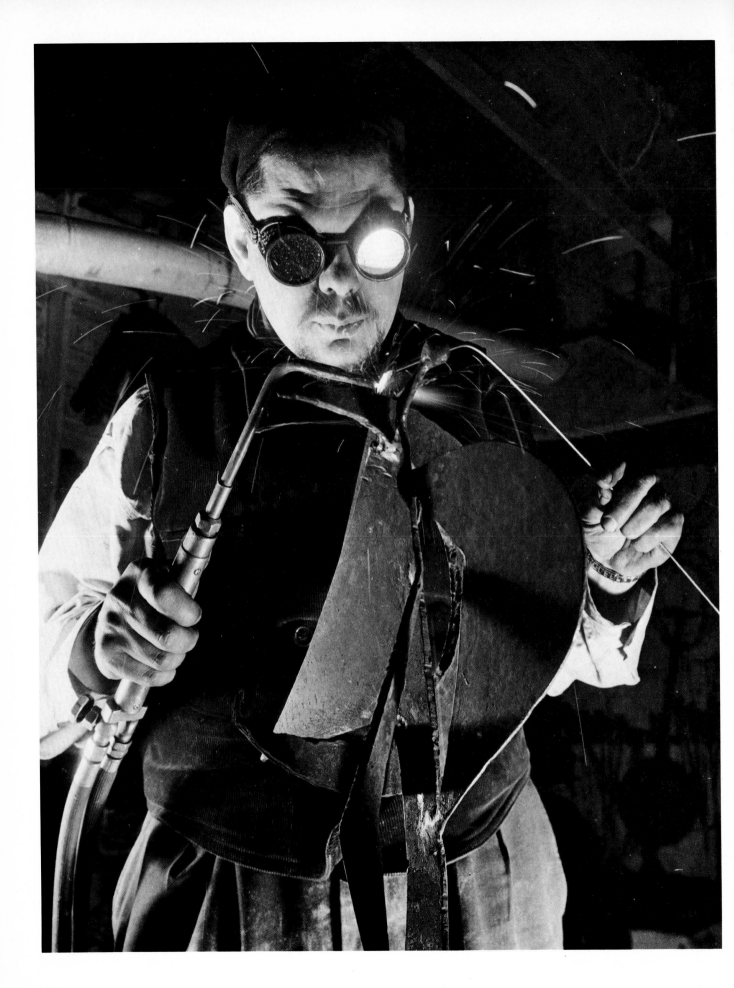

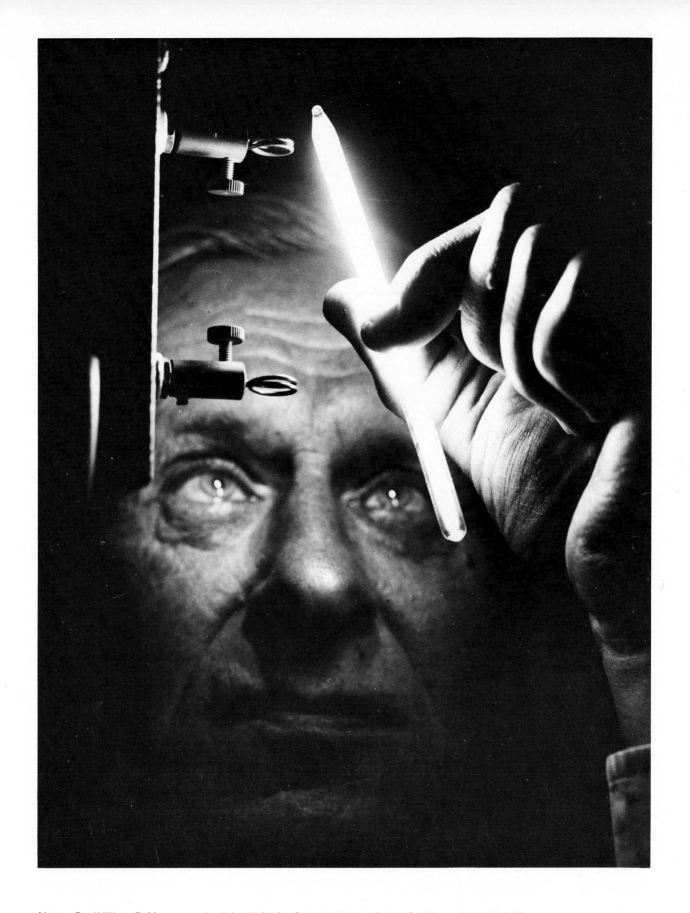

Above: Dr. William F. Meggers, physicist (1948). Opposite page: David Smith, sculptor (1940). Again, I used the "experimental" (i.e., unconventional) approach to express in my portraits more than merely a superficial likeness of the depicted persons by showing them involved in their work.

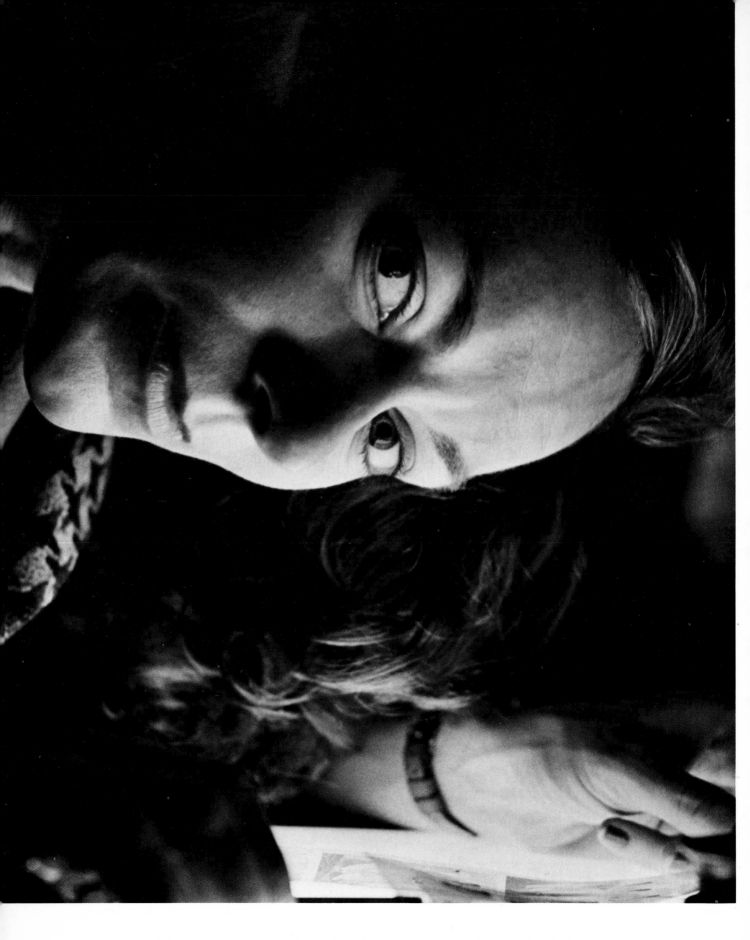

"Timmy," a *Life* photographer, editing her negatives on a light table (c. 1944).

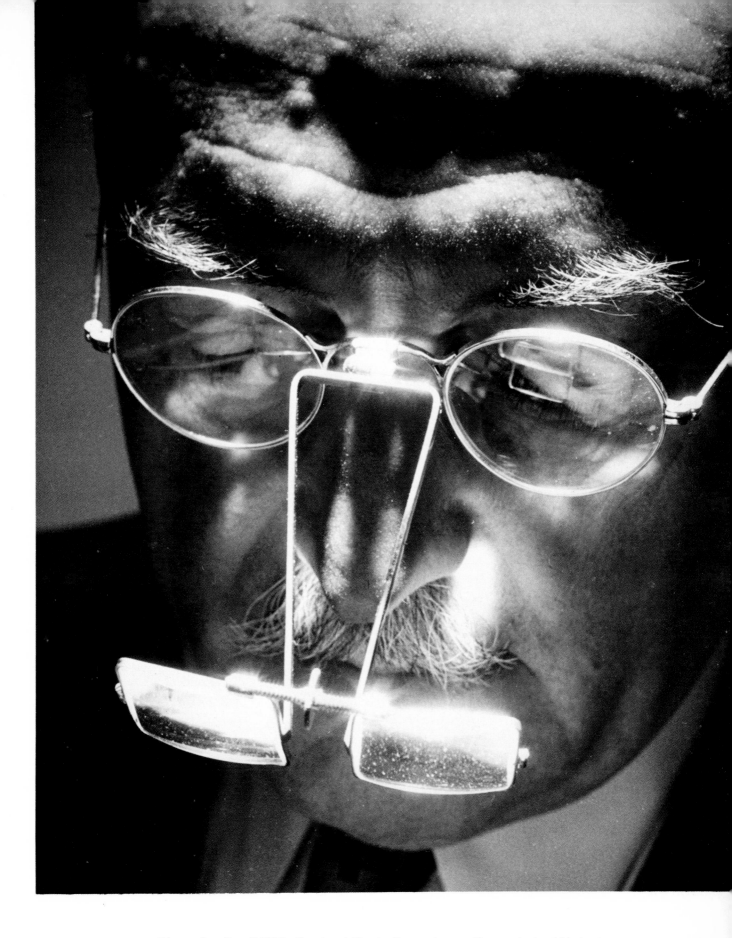

Diamond cutter (1955). Overhead illumination and magnifier are tools of his trade.

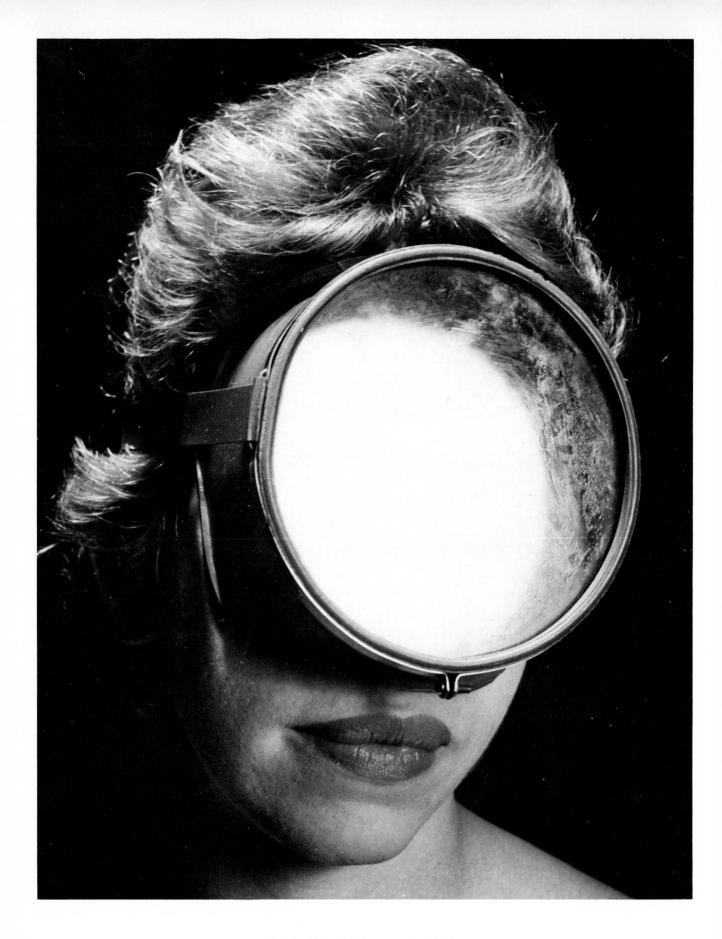

A lady diver with face mask (1955).

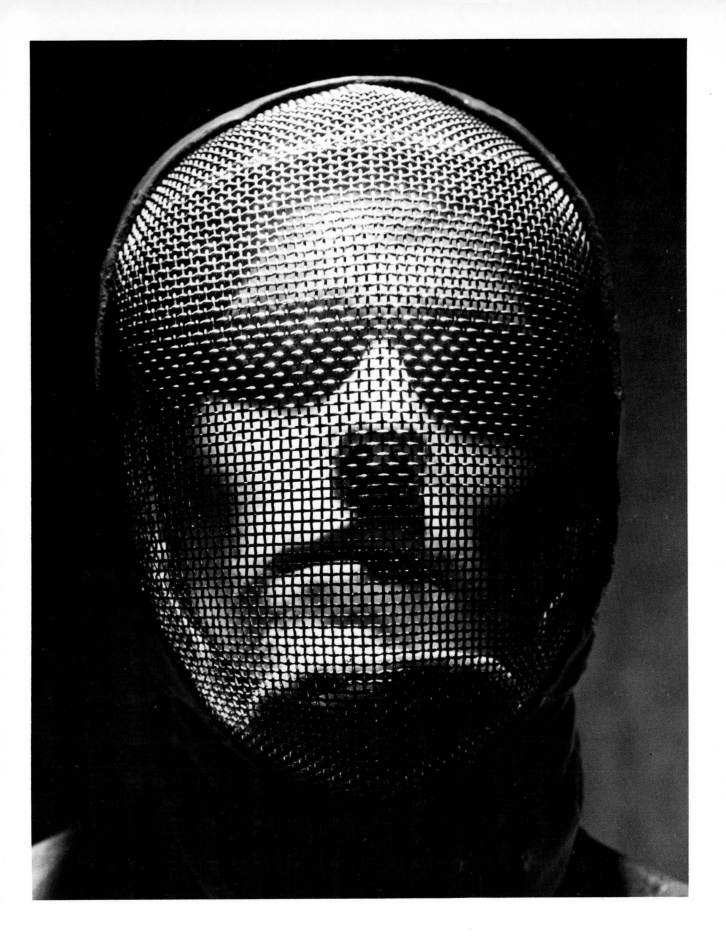

Stylized portrait of a fencer (1955).

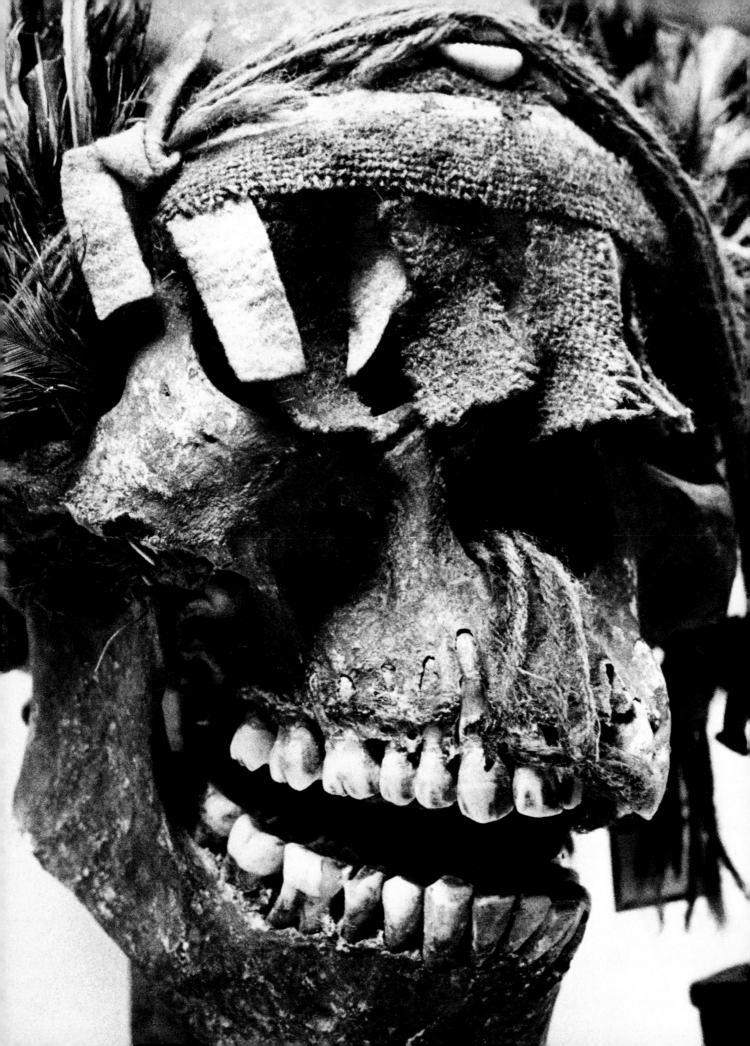

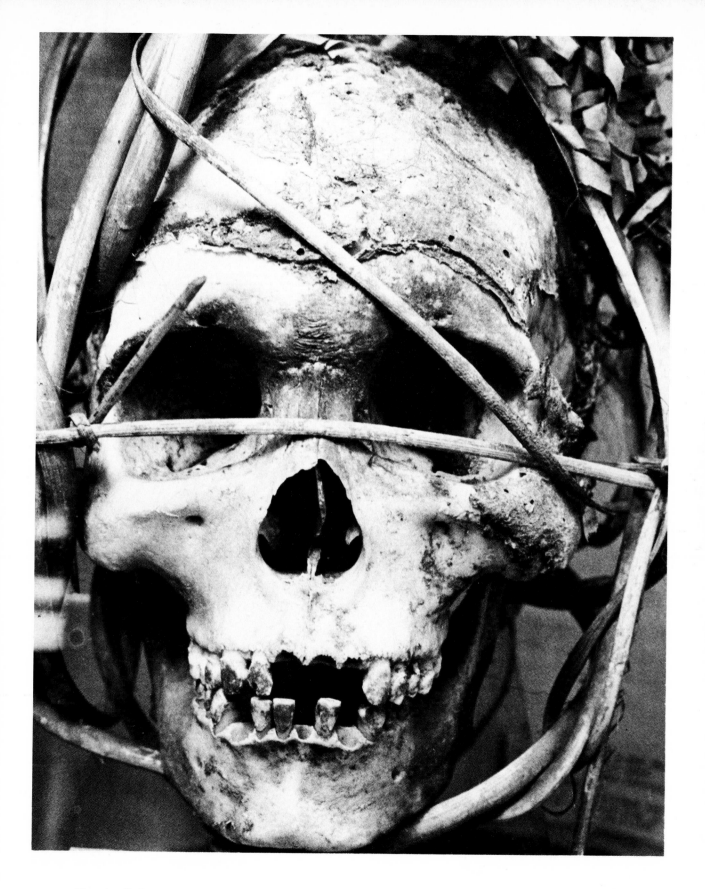

Two ritualistic skulls from the South Pacific (1969). In contrast to a conventional rendition, which would have shown these gruesome objects in their entirety (to include a maximum of factual information), I chose to crop them tightly, using an "experimental" approach in an effort to achieve a maximum of emotional impact.

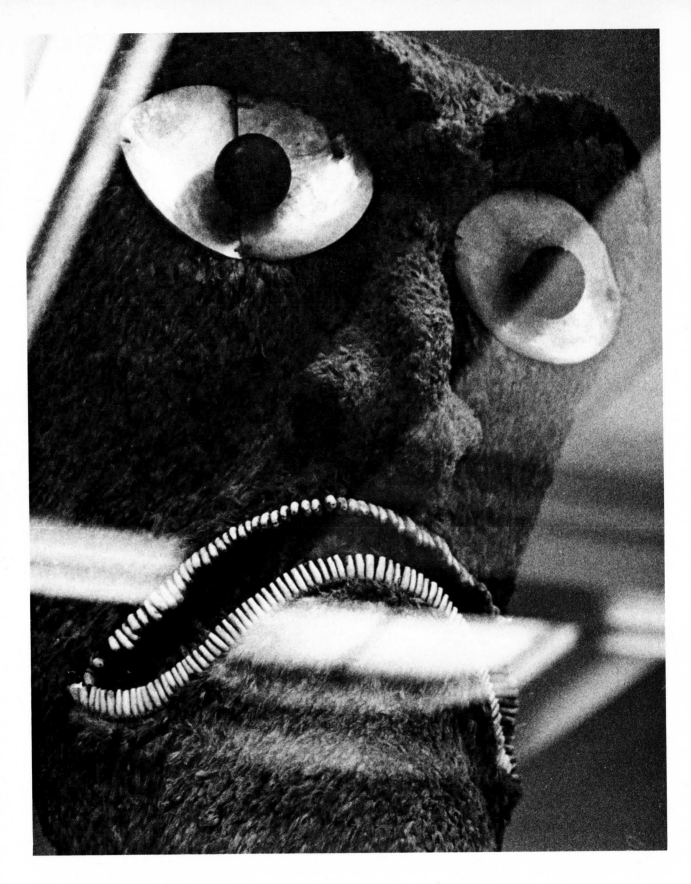

Two ritualistic masks from the South Pacific (1969). Instead of taking these fierce-looking objects out of their glass-front exhibition cabinets in order to avoid reflections—the traditional approach—I deliberately included streaks of reflected light in my composition to enhance the impression of these fantastic masks.

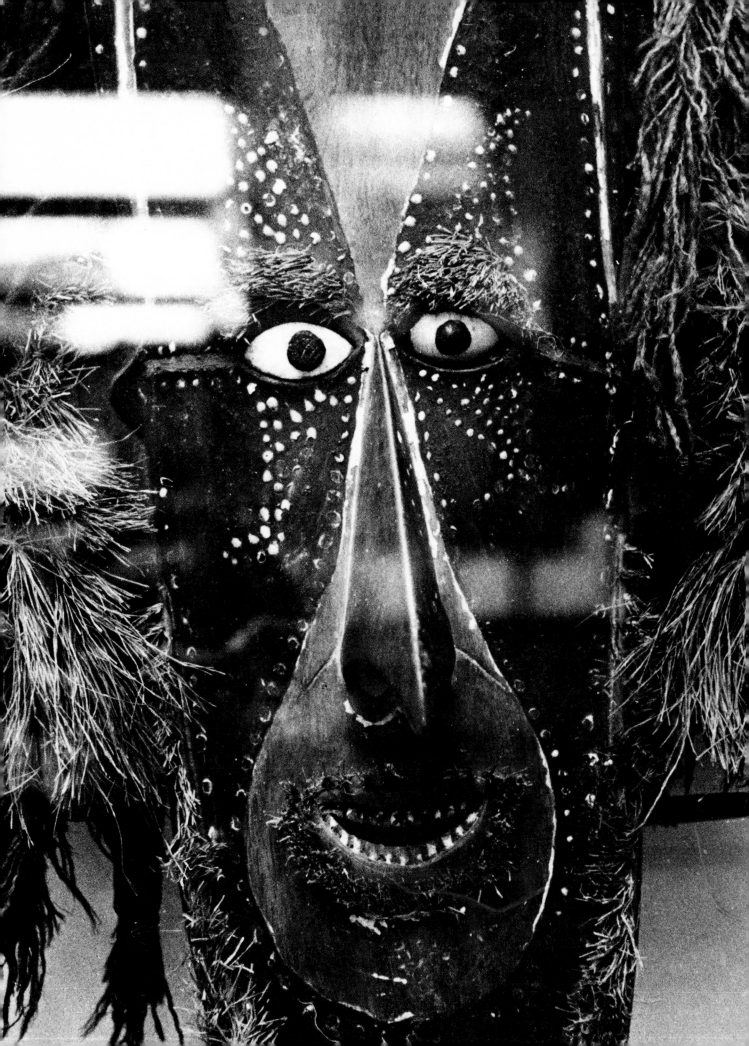

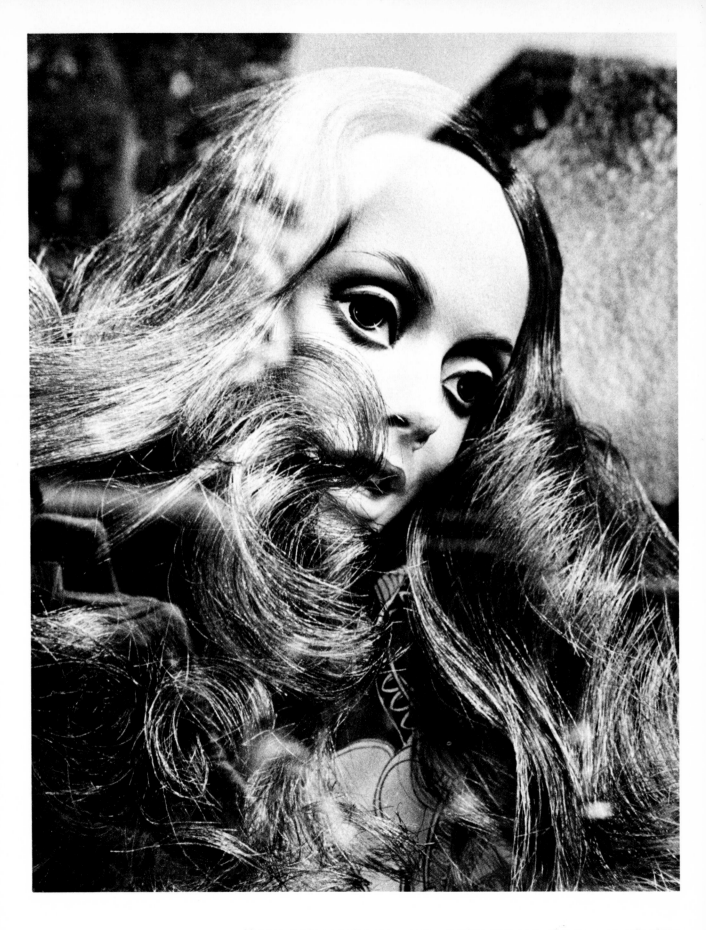

Mannequins in a London shop window (1969). Deliberate inclusions of reflections

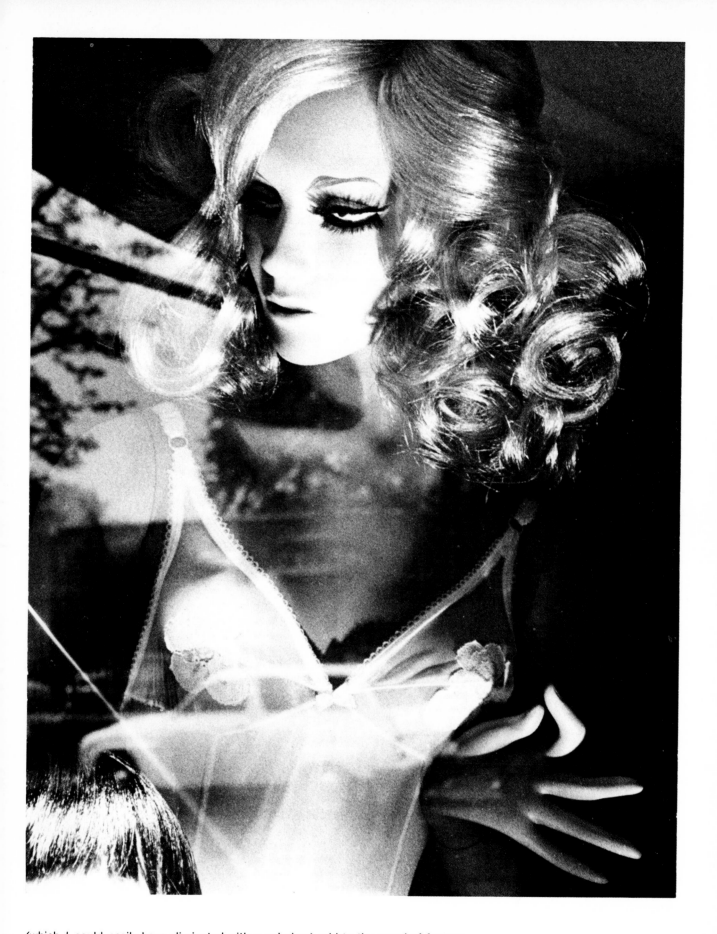

(which I could easily have eliminated with a polarizer) add to the mood of fantasy.

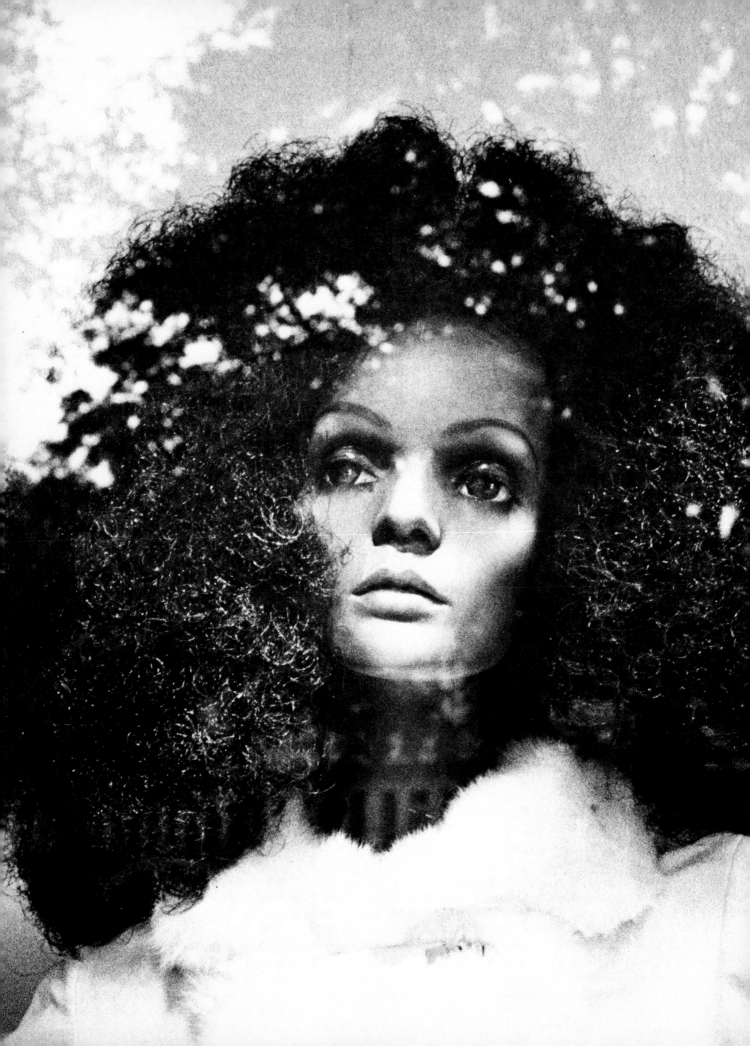

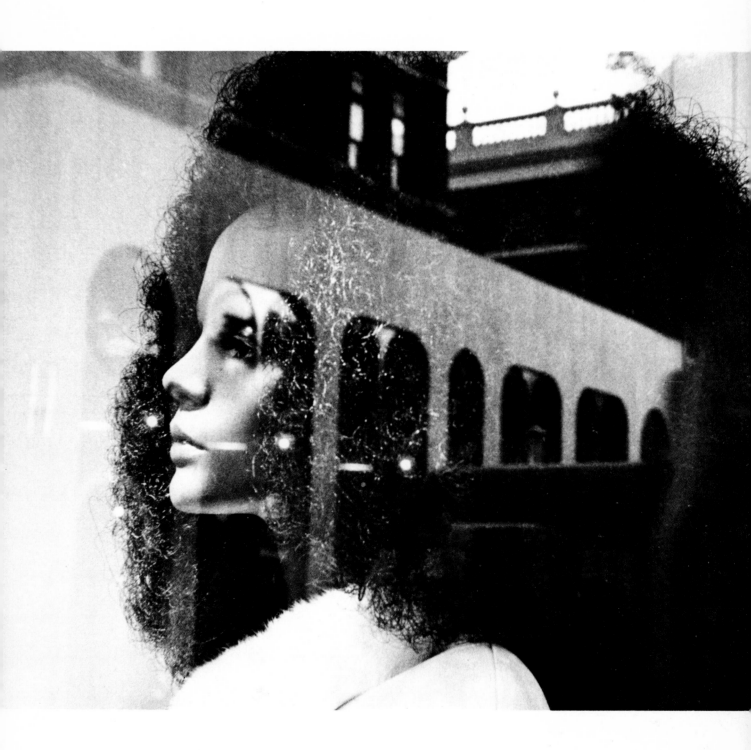

Mannequin in a London shop window (1969). Interpenetration of inner and outer space (via reflections in the window pane), creating a feeling of unreality, infuses this lovely head with a strange life of its own.

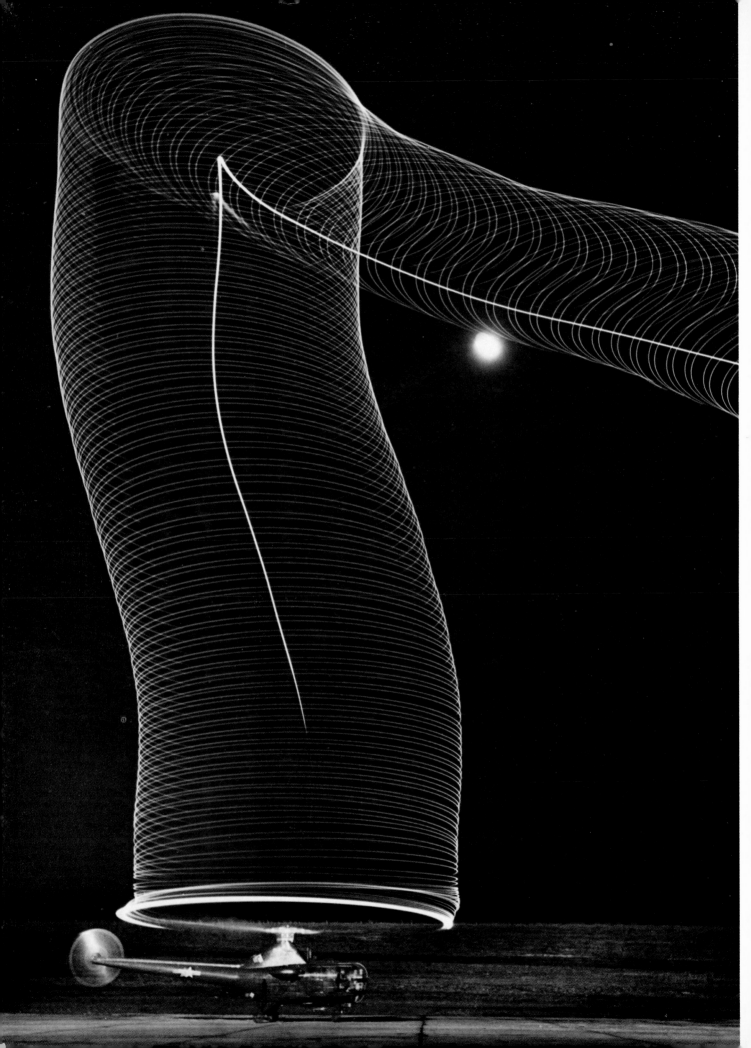

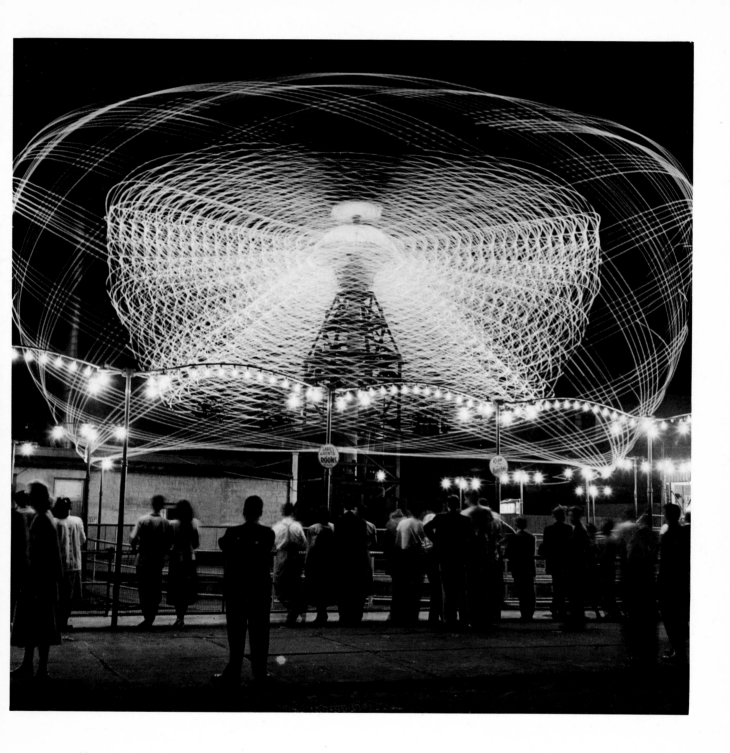

Above: the "Hurricane," Coney Island, New York (1949). Opposite page: helicopter takeoff at night (1949). An attempt at symbolizing motion in "still" photographs by means of time exposures through the line patterns generated by their moving lights.

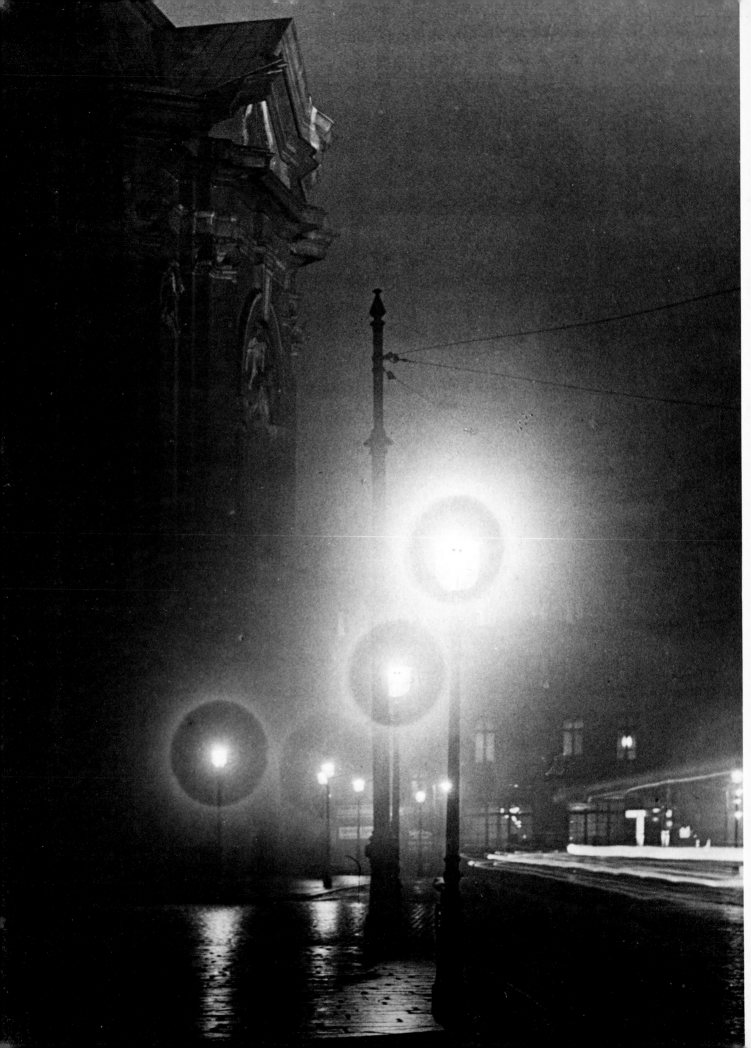

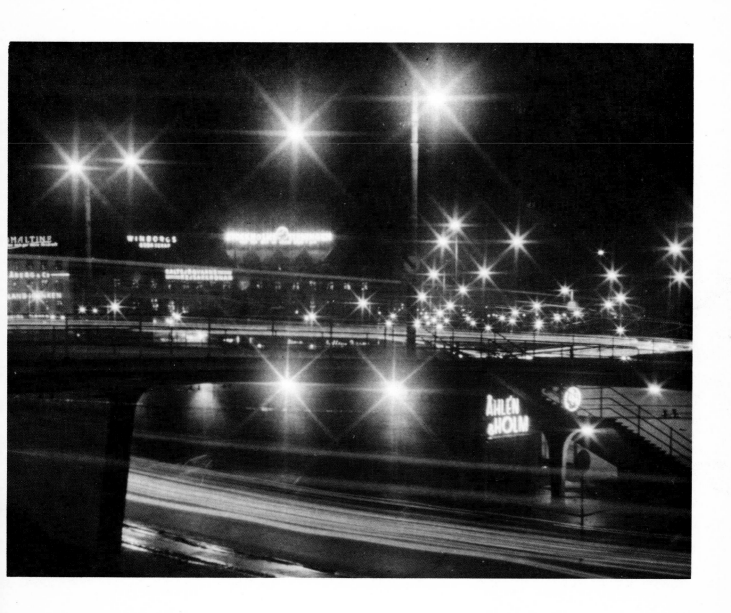

Above: night scene in Stockholm (1934). Opposite page: night scene in Hamburg, Germany (1930). Both images are based on experiments that I performed in order to find symbolic forms of photographic rendition that would better express the radiant character of direct light than the conventional blobs of white.

Epilogue

I can't say how often I have heard a young photographer exclaim: If only I could afford a Nikon, or a Hasselblad, or a Leica, I, too, could make great photographs. And the same sentiment is implied in all the ads in photo-magazines that, counting on snob appeal, urge their readers to "trade up" to some more expensive camera.

This, in my opinion, is baloney. A person who cannot make good photographs with a forty-dollar Instamatic would perform no better with a twelve-hundred-dollar Leica or a fifteen-hundred-dollar Hasselblad. Unfortunately, there are no "prize-winning" cameras; there are only prize-winning photographers. In itself, even the most costly camera is no more creative than a lump of clay. But, like a lump of clay, in inspired hands, it becomes a means of creation. What counts is the sensitivity and the degree of involvement, the artistic eye and the professional knowledge of the photographer. It is his mind that selects the subject for the picture, decides the manner of approach, chooses the means of graphic implementation, and guides the hand that holds the tool—the camera, which, in the last analysis, although indispensable for producing photographs, is nothing but a dead piece of machinery, analogous to the typewriter of the novelist or the piano of the pianist. Anybody can learn to type, but this does not make him a novelist. And anybody can learn to play a simple tune on the piano, but this is not the same as making music. Similarly, anybody can take recognizable pictures with one of our modern, automated, foolproof cameras, but this is not the same as making memorable photographs. The secret is in the seeing and the feeling, the awareness, the personal involvement, the interest on the part of the photographer who wishes, through his pictures, to communicate with other people. If he has something worthwhile to say and knows how to express himself, he will succeed. Otherwise, his pictures will be duds, no matter how illustrious the trademark of his camera.

ANDREAS FEININGER